GILBERT & GEORGE
THE SINGING SCULPTURE

TEXTS BY
CARTER RATCLIFF
ROBERT ROSENBLUM

THAMES AND HUDSON

Edited, designed, and produced by
ANTHONY McCALL/NEW YORK
11 Jay Street, New York NY 10013

Editor: Bruce Wolmer
Designer: John Bernstein

Published in Great Britain in 1993 by
Thames and Hudson Ltd, London

Printed and bound by La Cromolito, Milan, Italy

TABLE OF CONTENTS

REVISITING THE SINGING SCULPTURE
ROBERT ROSENBLUM

For those like me who had seen the New York debut of *The Singing Sculpture* back in September 1971 at the Sonnabend Gallery, seeing it again and in the same place, exactly twenty years later, produced the uncanny sensation that these two belated Victorian entertainers called Gilbert & George had never interrupted their original presentation. Year after year, it seemed, in the same room and with the same mural backdrop of landscape drawings, this pair of automatons had simply repeated, again and again, their music-hall act. Still more miraculously, they appeared barely to have aged or to have altered the length of a sleeve or cuff. Moreover, not a smudge of the metallic and colored makeup had changed, nor was there the slightest evidence of wear on their immaculately humdrum uniforms of worsted suits, nylon shirts, patterned ties and polished brogues. With the mindless duty and infinite stamina of programmed robots, they merely went on fulfilling the high-minded obligation spelled out as a creed in one of the captions of the background drawings ("We step into the responsibility suits of our Art"), going on and on with the show whether there was a crowd to watch them or, at long stretches, nobody around at all. Awesomely singular, timeless and tireless as this superhuman (as well as subhuman) feat had initially been, it also became, for second-time-round spectators, an occasion for layered retrospection. Given the eventful two decades—an entire generation—we have had for *The Singing Sculpture* to settle in, this unclassifiable work of art (both ephemeral and permanent, human and mechanical, alive and inanimate, theater and sculpture) has nevertheless begun to take a clearer place in history, both past and present.

For most New Yorkers in 1971, it was *The Singing Sculpture* that launched the career of Gilbert & George, a spectacular debut that seemed to arrive from a distant planet, though one obviously rotating around the setting sun of the British Empire. So unique and memorable was the event that their art was usually thought to consist exclusively of live theater pieces, which meant that they could be forgotten about temporarily until they went on tour again. In New York, this meant waiting five years for the next show, but that at least turned out to be more than worth the wait. I still recall the dumbfounding shock of Gilbert & George's entry in their 1976 presentation of *The Red Sculpture,* again at the Sonnabend Gallery, when the two robot artists appeared once more in their instantly recognizable civilian uniforms, but this time with their exposed heads and hands covered, from hair to fingernails, in the reddest of red paint. It was like a shriek of violence totally squelched by the solemn, symmetrical narrative movements of this nine-part, 90-minute-long enactment of what seemed to be the repressive rituals of a very British life both inside and outside the proper confines of domesticity.

Nevertheless, their increasingly famous double persona, initiated in three, not quite living dimensions in *The Singing Sculpture* and resurrected five years later in *The Red Sculpture,* was also penetrating the New York art world of the early 1970s more quietly and subtly in other kinds of ephemera—personal mailings; tidy, scrapbooklike arrangements of small, black-and-white personal photos or cheap, souvenir-shop postcards—all variations, it now appears, of the melancholy, constraining environment they first created as we heard and saw their living sculpture "Underneath the Arches" over and over again. It was irrevocably established then, for example, that their art would be twinned forever in sight, sound, concept and labor, a pact that has remained

so steadfast that they and their work are unthinkable in the singular. It was also made clear then they were no less irrevocably subjects of Her Majesty, dressed like respectable ambassadors of their country and immersed in the center of a great insular culture that could encompass an entire world. And it was no less apparent that for them art was work—rigorous, no-nonsense duty, with regular hours and physical discomforts silently borne, an odd hybrid of the factory and the libertine world of modern art galleries.

Their principles, in fact, endured, and the shadows cast by *The Singing Sculpture* continue to lengthen over the decades. We have seen how their paired presence, playing the roles of London music-hall entertainers singing to an imaginary audience that has in good part known the threats and realities of dire poverty, was constantly amplified in the 1970s and 1980s, when they became a kind of Dante and Virgil exploring the Stygian depths of London, documenting in increasingly bold formats the dreary facts of homelessness, hopelessness, drunkenness and bleakness in the East End world they know from the inside out. *The Singing Sculpture* set into motion, too, the impeccable, regimented precision of their art, where the actions of mirrored, playing-card figures are fixed in checkerboard designs that turn private pathos and desire into timeless abstractions, reflecting the stiffest of British upper lips. The robotic regimentation of *The Singing Sculpture* would soon be transformed in their art into huge visual parade grounds, where heraldic patterns of imperial pageantry camouflaged the exposure of the seamier sides of British society.

If the 1991 presentation of *The Singing Sculpture* recalled the rock-bottom roots of Gilbert & George's later art and life, it also began to look this way and that in both local and international directions. For instance, it could hardly have been lost on a New York audience that the heartbreaking theme of this old-fashioned, bittersweet entertainment—homelessness in faraway, long-ago London, when street people who, in the ironic lyrics of the Flanagan and Allen music-hall song, never cared for "The Ritz"

found protection and solace by sleeping underneath the arches of the Thames embankment—was shockingly timely, a jolt from another era and another city that elicited far more poignancy and guilt in 1991 than it did in 1971. The experience, in fact, reminded me of the trip I had made to the Yale Center for British Art in 1987 to see an exhibition, "Hard Times: Social Realism in Victorian Art," which up there in academe seemed like a remote, Dickensian time capsule of another century's desperate poverty, but then, on my return from New Haven that evening, came back to frightening life right inside Grand Central Station, which was fast becoming a sordid, unofficial hospice for New York's shelterless nomads.

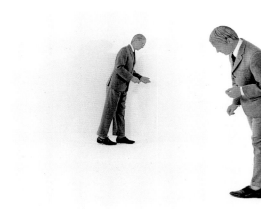

Gilbert & George,
The Red Sculpture, 1976

Gilbert & George, *Life*
(from *Death Hope Life Fear*),
1984. 422 x 250 cm

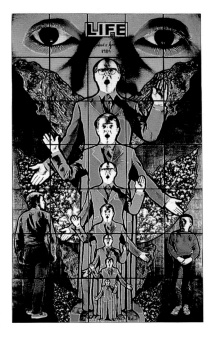

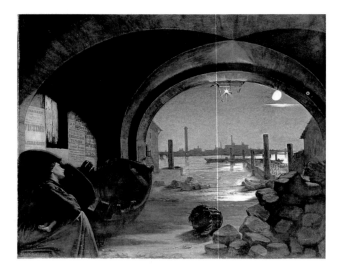

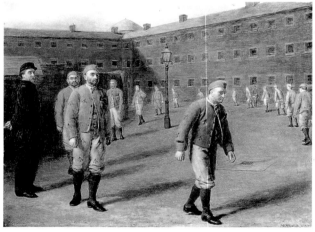

Augustus Egg,
Past and Present,
Number 3, 1858

William Frith,
Retribution, 1880

Georges Seurat,
Le Chahut, 1890

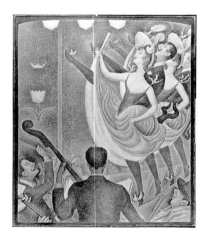

But apart from the chilling and unexpected topicality of Gilbert & George's particular choice of text, the work's general mood of lower-class resignation to the grimmest of destinies—urban misery amid middle-class proprieties and mind-numbing, repetitive labor—is one that seems deeply rooted in the artists' own nostalgia for a Victorian past that, especially in London's Spitalfields, where they live, has managed to endure late into the twentieth century. Even in terms of the stark polarity of city versus country, *The Singing Sculpture* clings to the world of *Hard Times.* What could mirror more succinctly this familiar Victorian duality than the contrast of Gilbert & George as downtrodden urban entertainers seen against their almost neo-Pre-Raphaelite charcoal drawings of the sweet pastoral Arcadia lying beyond London's industrial grime? It is telling, too, that one of the more famous Victorian narrative paintings, Augustus Egg's three-part *Past and Present* (1858) at the Tate Gallery, concludes its drama of an unfaithful wife's fall from conjugal propriety to lonely squalor literally underneath the arches, where she finds her final refuge below the vaults of a bridge near the Strand, from whose shelter she can stare at the bleak night sky.

Aside from such London specifics, what could be more Victorian than Gilbert & George's factorylike rendering of human beings forced into repetitive, regimented discipline? Here again, a nineteenth-century narrative painting comes to mind: the last image, *Retribution,* from William Frith's series The Road to Ruin (1880). In this cruelly didactic finale, we are taken to the starkly utilitarian, quadrangular courtyard of Millbank Gaol, where the prison inmates, now including the sinner-hero, do their exercise rounds with the precision of robots whose masked feelings we can only guess at. Knowing Gilbert & George's obsession with the straitjacketing rules, regulations and furniture of the Victorian world, we can guess how deeply they might respond to Frith's punishing transformation of men who have erred into the impersonal cogs of a moral machine. As for the particular pathos of once individual humans who have been turned into impersonal

automatons, one of the heartbreaks behind *The Singing Sculpture,* it can be felt on even loftier levels of later nineteenth-century painting, most intensely in the work of Georges Seurat, who understood as no one else how the burgeoning new world of popular entertainment re-created both performers and spectators as clockwork parts of a heartless machine. His gaslit image of a Paris music hall, *Le Chahut* (1890), says it all. The belt-line of dancers kicking high to the conductor's metronomic beat triggers automatic smiles of satisfaction in the equally robotic audience, a bizarre prophecy of television's "laugh track."

Yet just as it has begun to look more clearly backward to the nineteenth-century world of humans beaten into monotonous submission by the wheels of industry, so too has *The Singing Sculpture* begun to take its place more firmly within the art of its own time. The international domain of gently nostalgic and ironic historical retrospection which, for want of a better name, we call "Post-Modernism," has a precocious point of reference in *The Singing Sculpture,* which among its countless heirs can include the revivalist life and art of the young American duo, David McDermott and Peter McGough, who usually dress as Edwardian gentlemen and who, in the words of "Underneath the Arches," "dream their dreams away" in paintings, photographs and living reconstructions of more proper Anglo-Saxon decades past. And if we recall, too, that *The Singing Sculpture* was first presented as early as 1969 in London, at St. Martin's School of Art, we may realize that it is also a landmark in the ongoing, international history of performance art, contributing to that wave of events in which artists themselves—Bruce McLean, Jannis Kounellis, Joseph Beuys, Scott Burton—played roles in, and therefore were literally fused with, theatrical spectacles that blurred the familiar boundaries between artists and their art. And is it just a coincidence that it was also in 1969 that Duane Hanson launched his career as a sculptor who was to invent a science-fictional breed of human simulacra who had neither soul nor pulse and who could exist for eternity in museums and

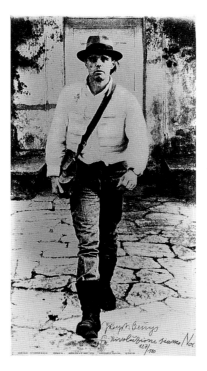

Joseph Beuys,
We Are the Revolution,
1972

Gilbert & George,
The Alcoholic, 1978.
240 x 200 cm

homes as weird embalmments of people, things and times past? *The Singing Sculpture,* in fact, now seems to lie at the historical roots of a whole new world of humanoids that carry us right up to the creations of Robert Gober and Jeff Koons, and that with appropriate timelessness for this backward glance at *The Singing Sculpture* have now been anthologized in an exhibition, "Posthuman," that opened in June 1992 at Lausanne's Musée d'Art Contemporain (F.A.E.). With its uncanny ability to endure in our imagination and, given the twentieth anniversary presentation, even in visible, audible fact, Gilbert & George's pair of motorized entertainers, we eerily feel, may well continue singing long into the twenty-first century and beyond.

UNDERNEATH THE ARCHES

The Ritz I never sigh for
The Carlton they can keep
There's only one place that I know
And that is where I sleep

Underneath the Arches I dream my dreams away
Underneath the Arches on cobblestones I lay
Every night you'll find me tired out and worn
Happy when daylight comes creeping heralding the dawn
Sleeping when it's raining and sleeping when it's fine
Trains travelling by above
Pavement is my pillow no matter where I stray
Underneath the Arches I dream my dreams away

By Flanagan and Allen, 1932

THE SINGING SCULPTURE

PHOTOGRAPHS BY JON & ANNE ABBOTT

The following photographs record the presentation of *The Singing Sculpture* at Sonnabend Gallery, New York, September 21–28, 1991, from 3 to 6 p.m. each day, in combination with the exhibition of Gilbert & George drawings, *The General Jungle,* that continued until October 12. The combined presentation and exhibition was an exact re-creation of the original show that opened Sonnabend's New York gallery in September 1971.

The photographs show the repeating sequences of *The Singing Sculpture.* (For one group of photographs the drawings were removed from the walls, and no audience was present.) As the song plays, Gilbert and George, one holding a stick, the other a glove, rotate with fluid, mechanical movements and gestures, singing along as they turn. At the song's end, whoever is holding the glove steps down and restarts the cassette, then returns to the table. They exchange the stick and the glove, and as the song begins again, they begin again.

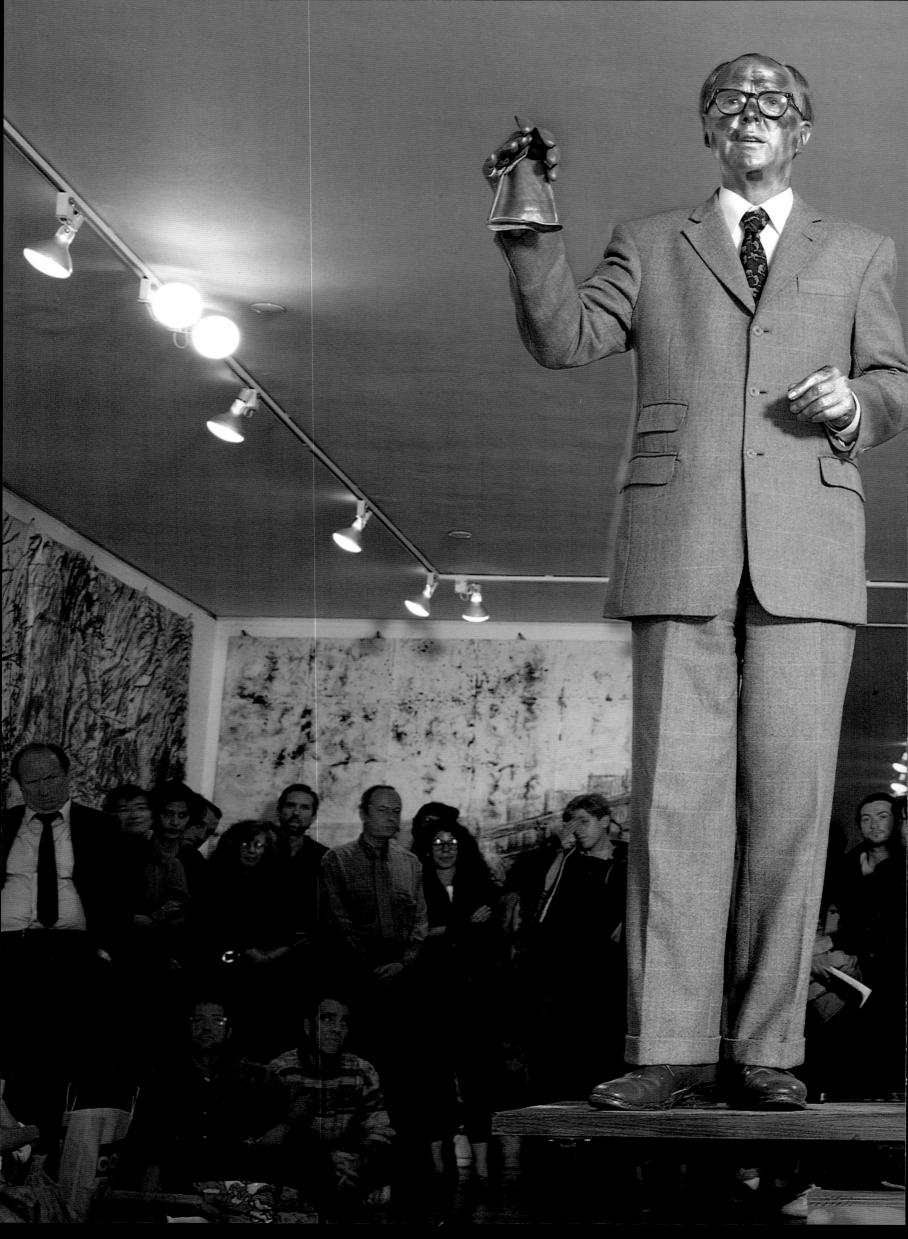

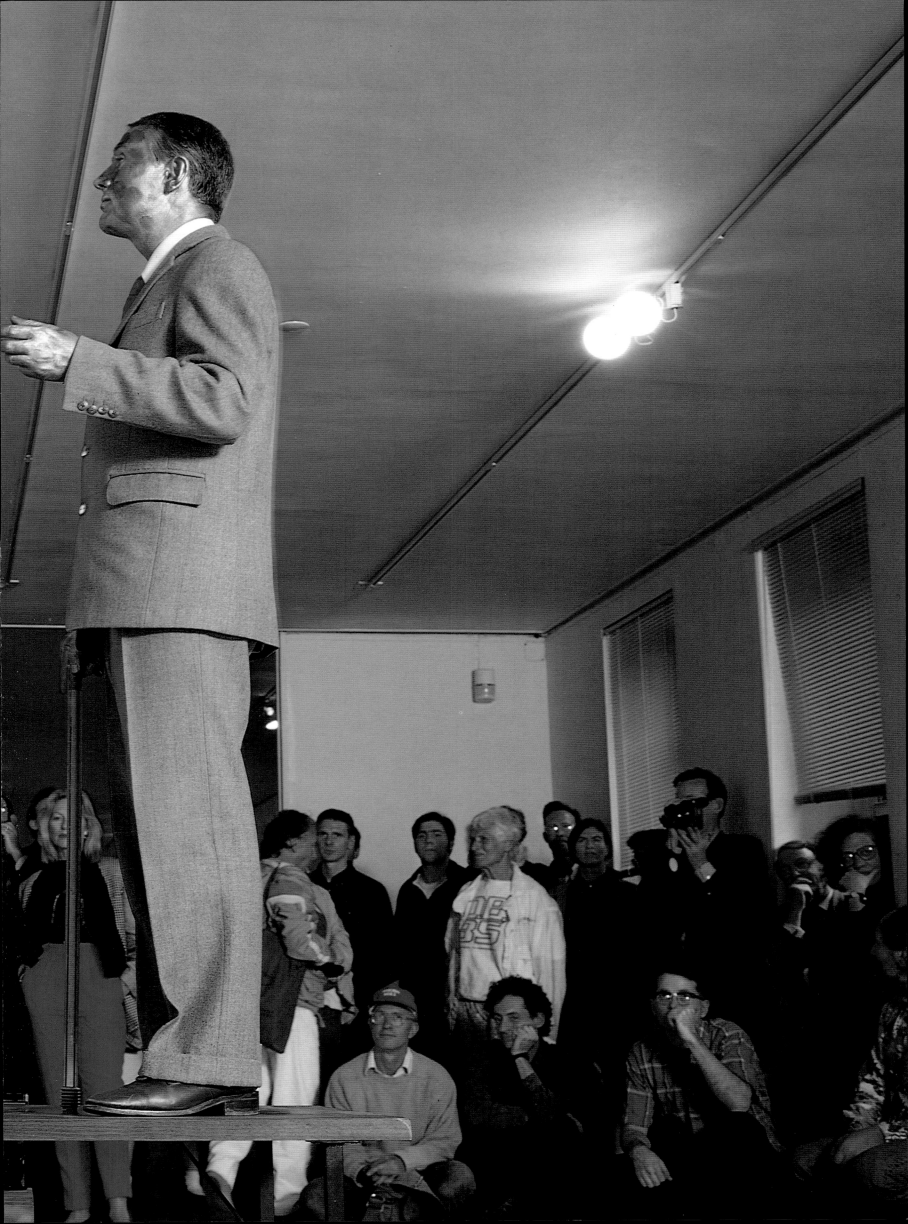

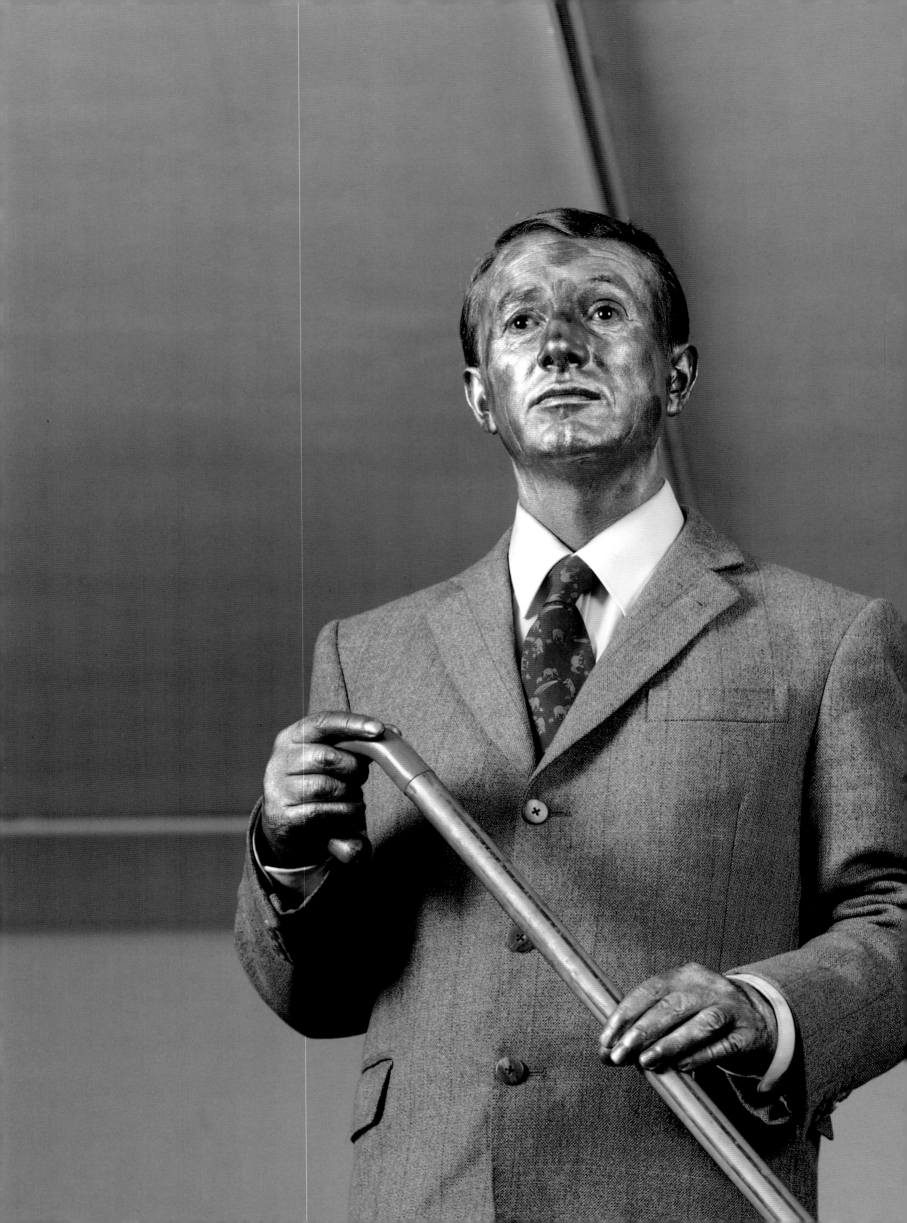

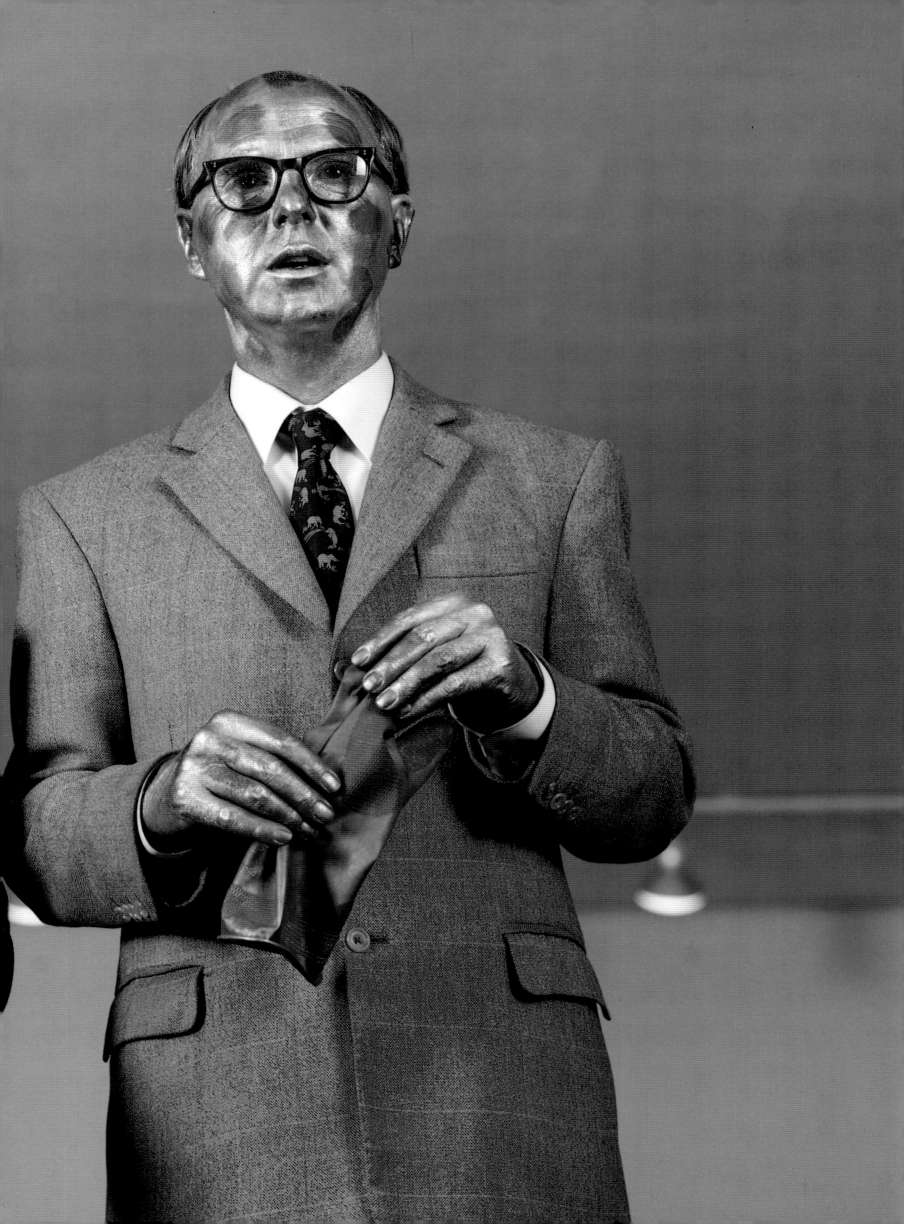

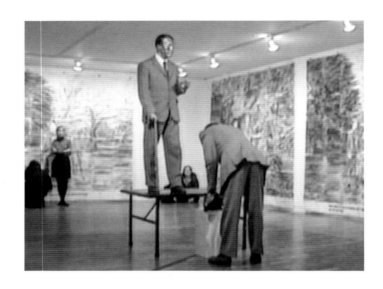

GEORGE STEPS DOWN AND RESTARTS
THE TAPE OF THE SONG,
THEN RETURNS TO THE TABLE.
HE AND GILBERT
EXCHANGE STICK AND GLOVE
AND BEGIN AGAIN.

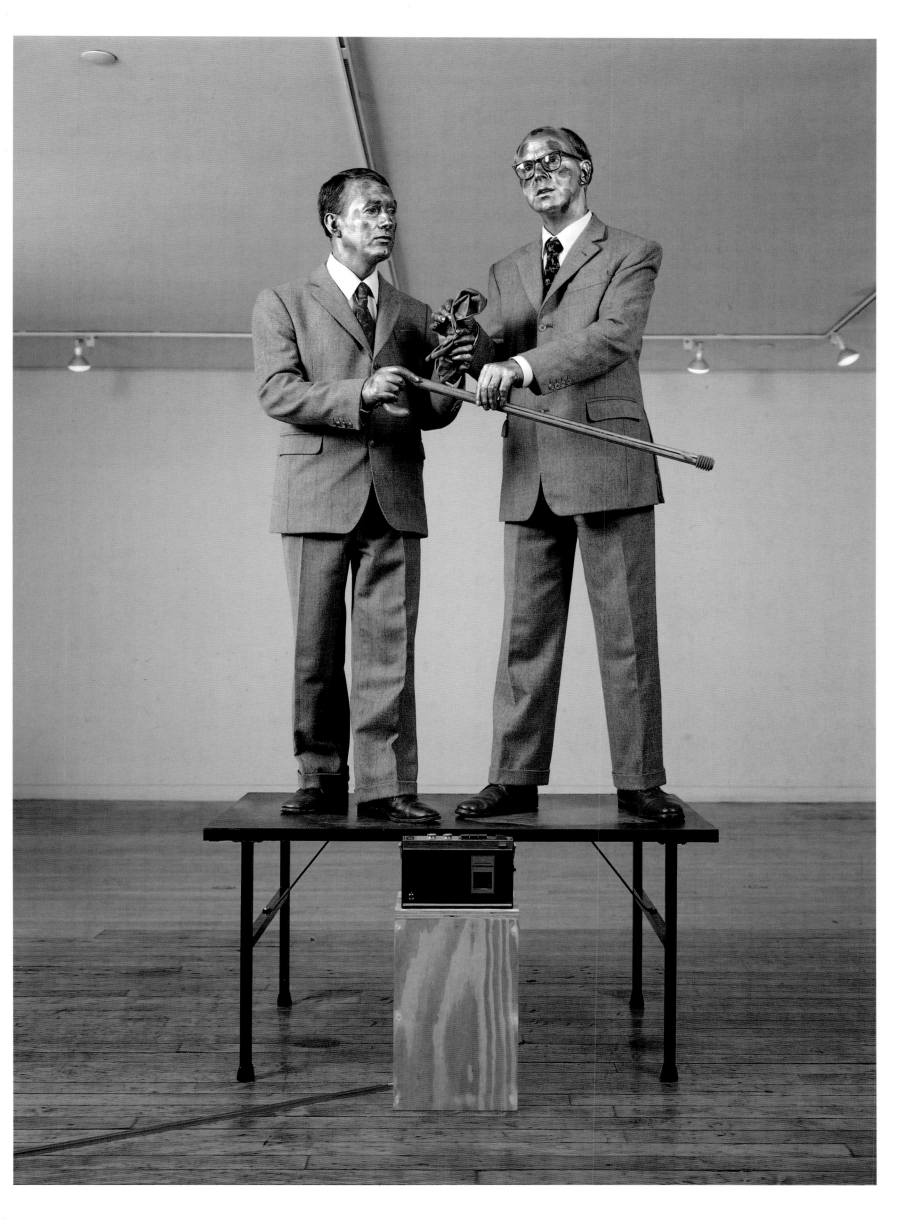

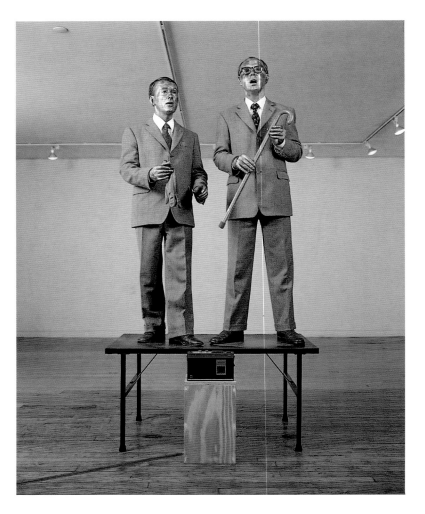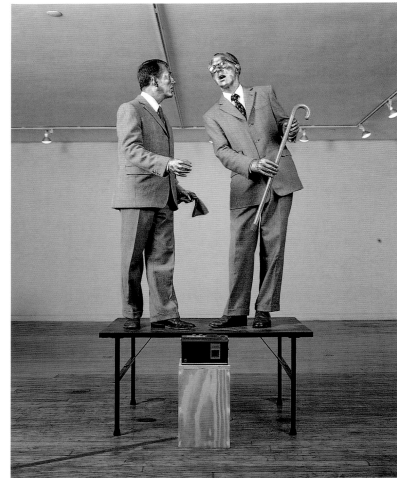

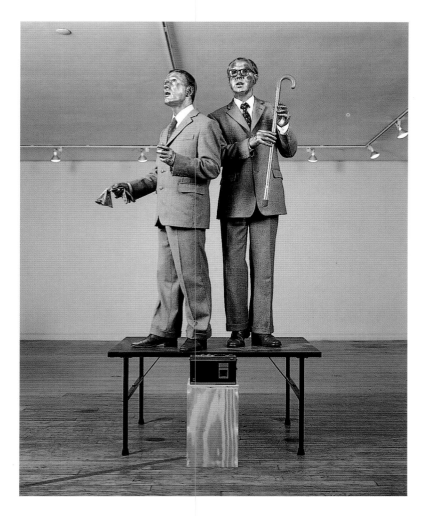 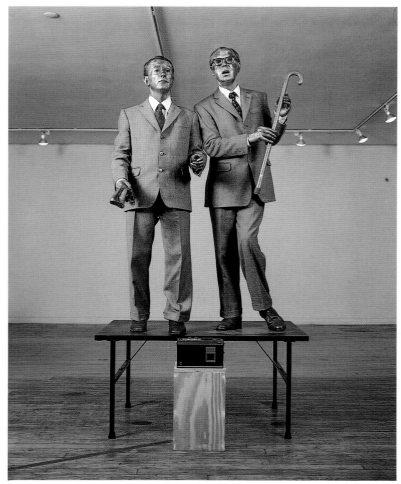

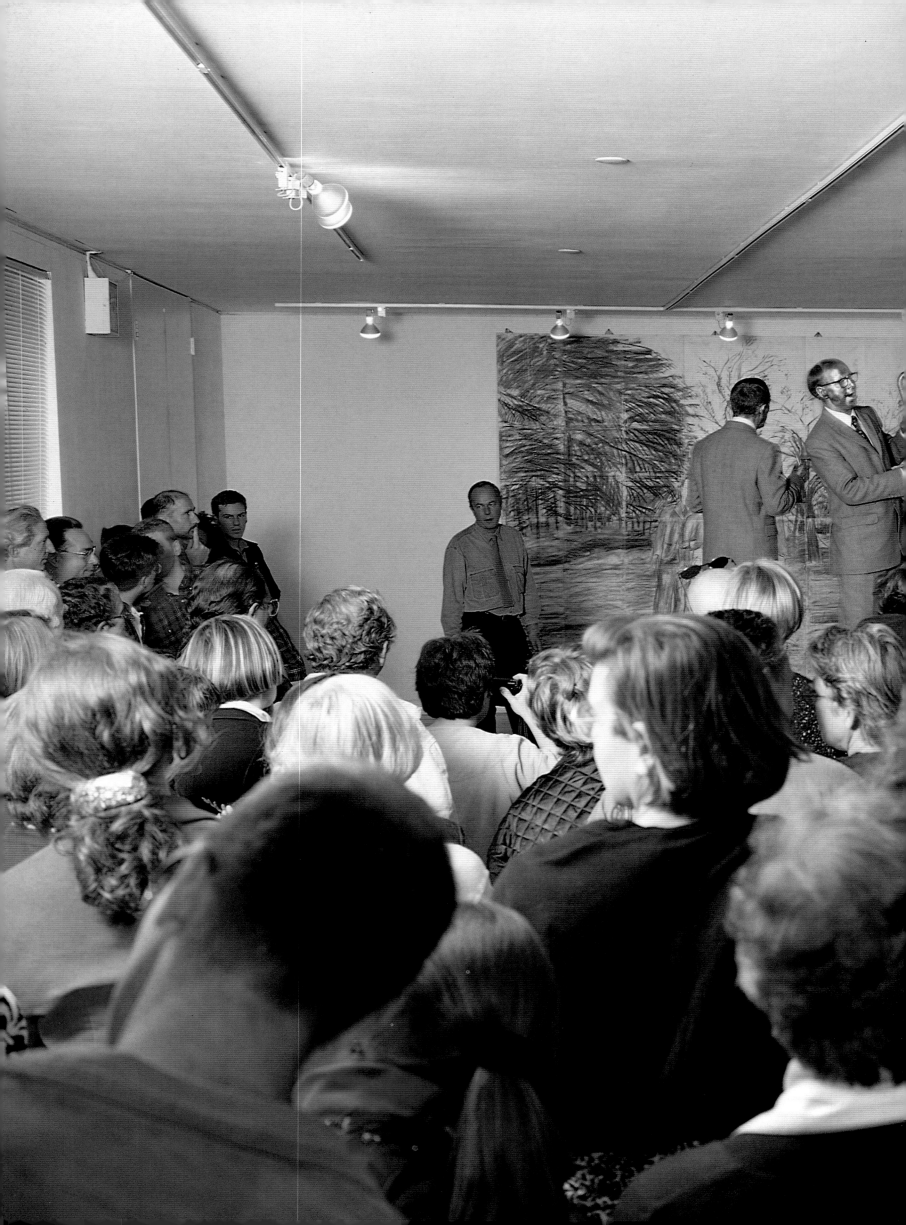

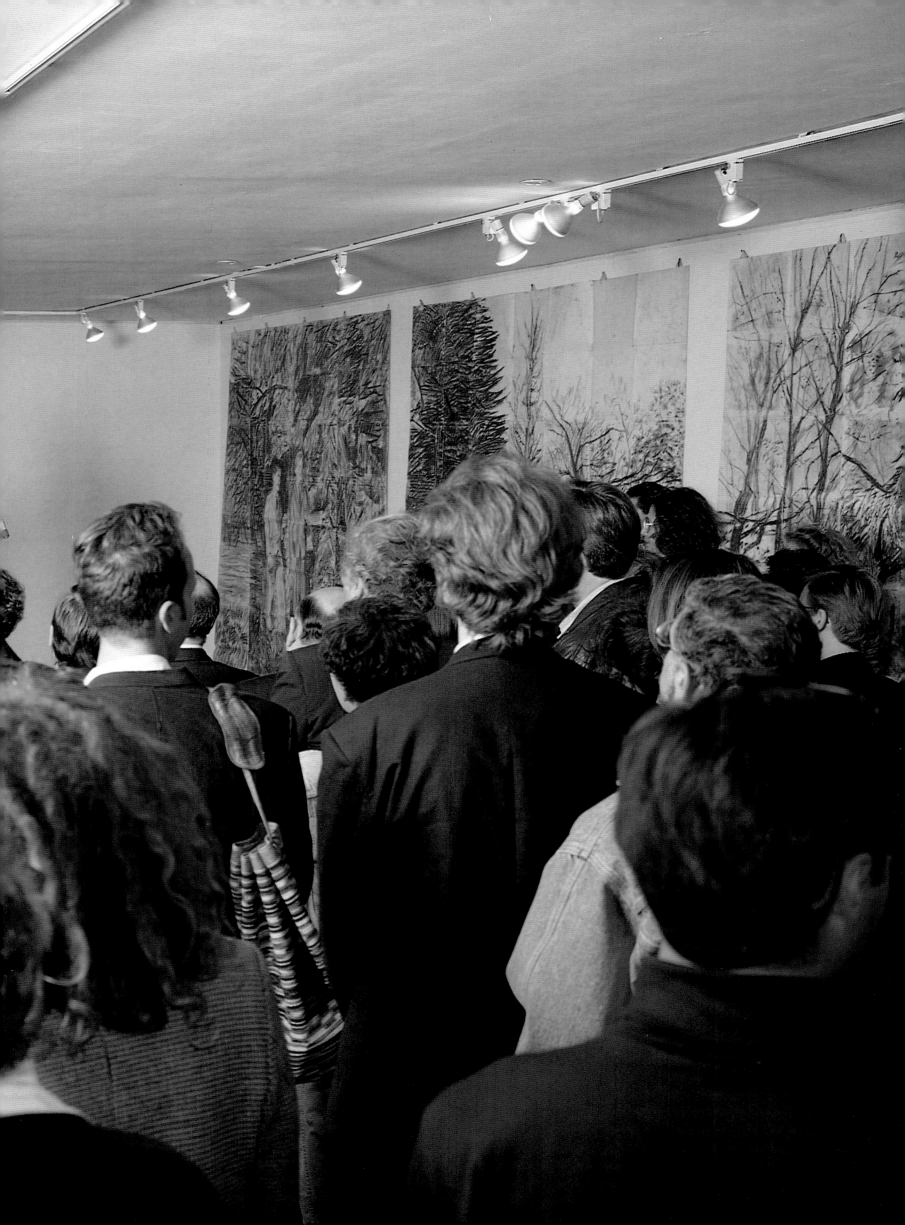

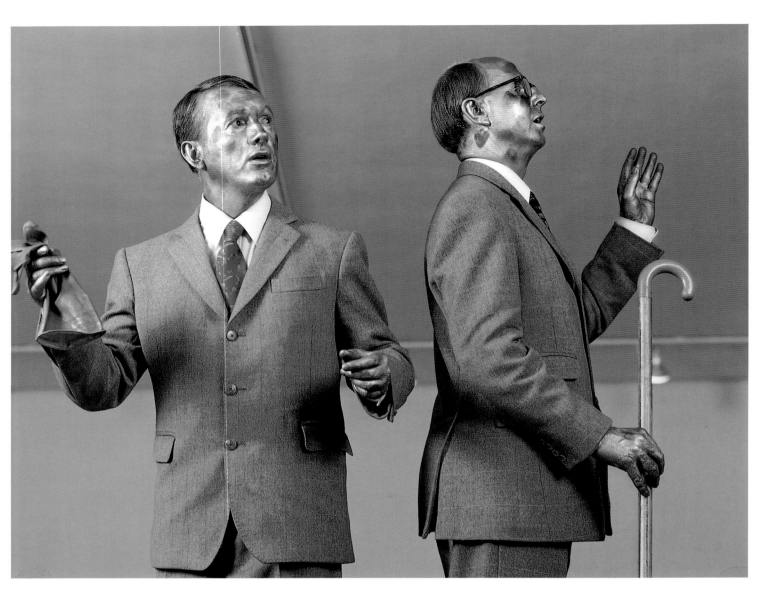
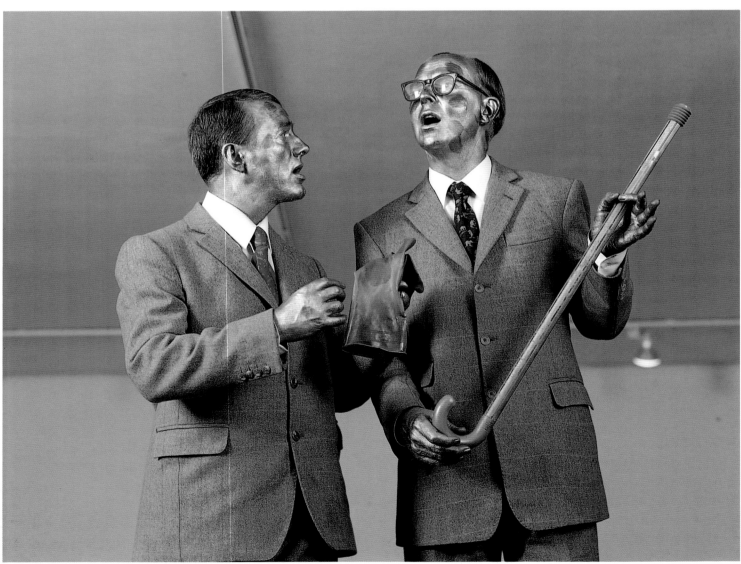

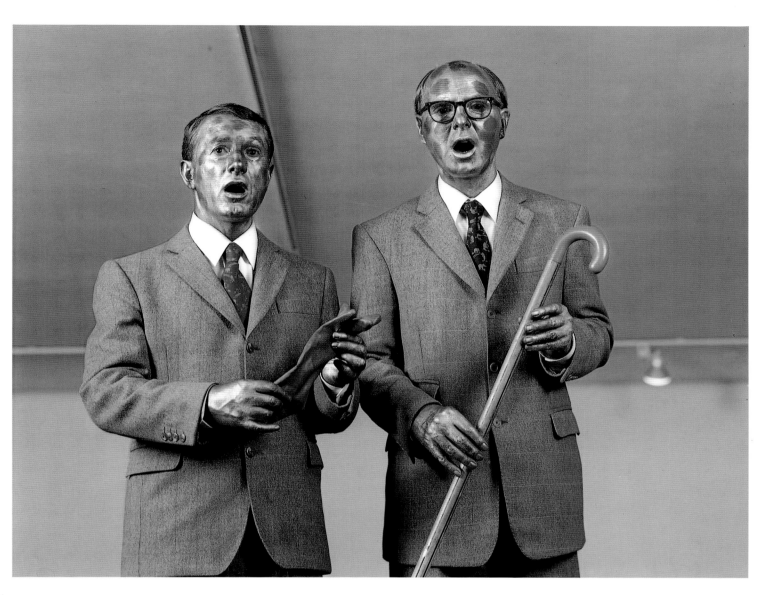

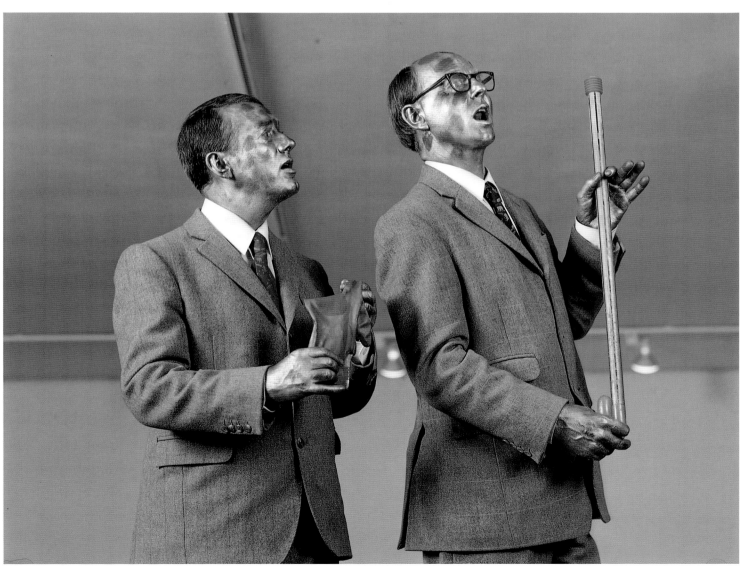

AFTER GILBERT HAS RESTARTED
THE TAPE OF THE SONG,
HE AND GEORGE
EXCHANGE STICK AND GLOVE
AND BEGIN AGAIN.

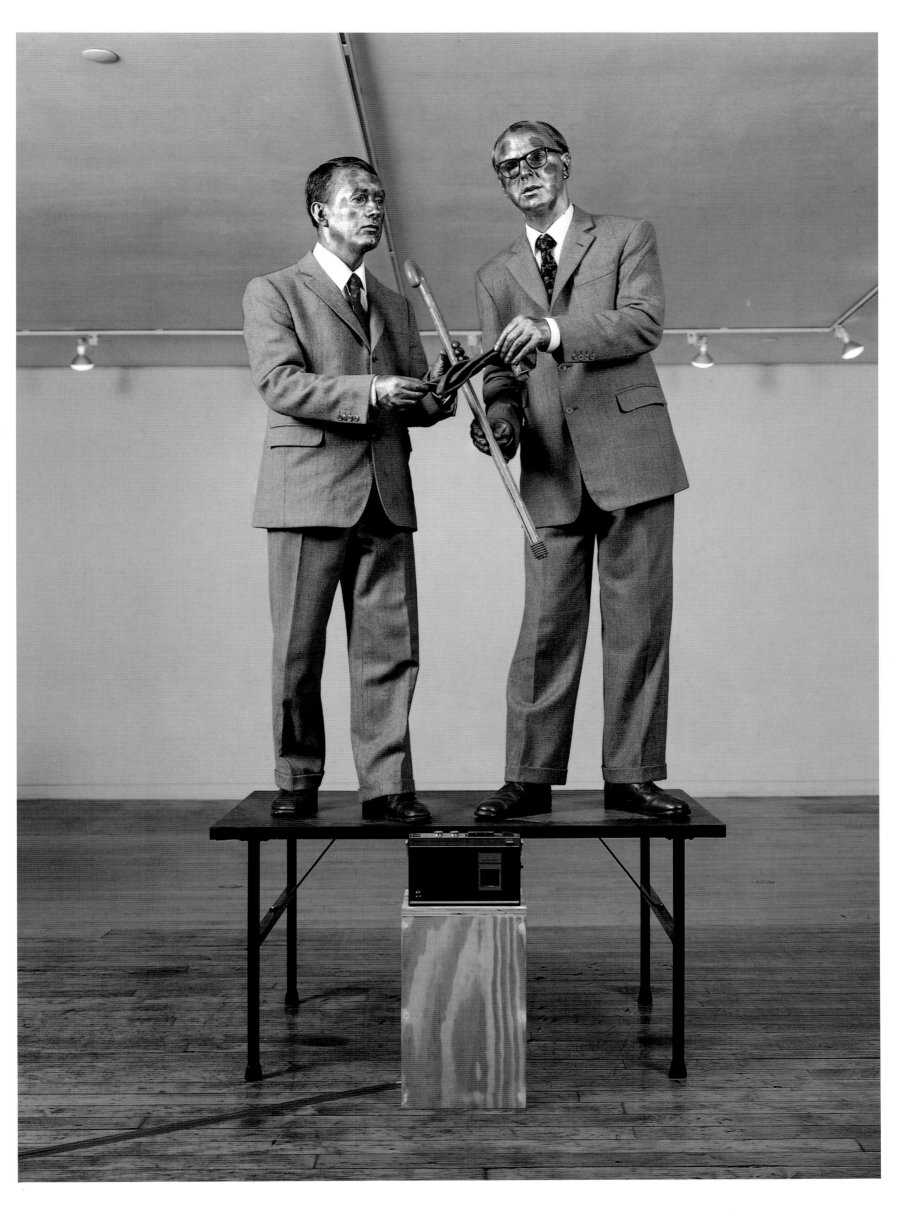

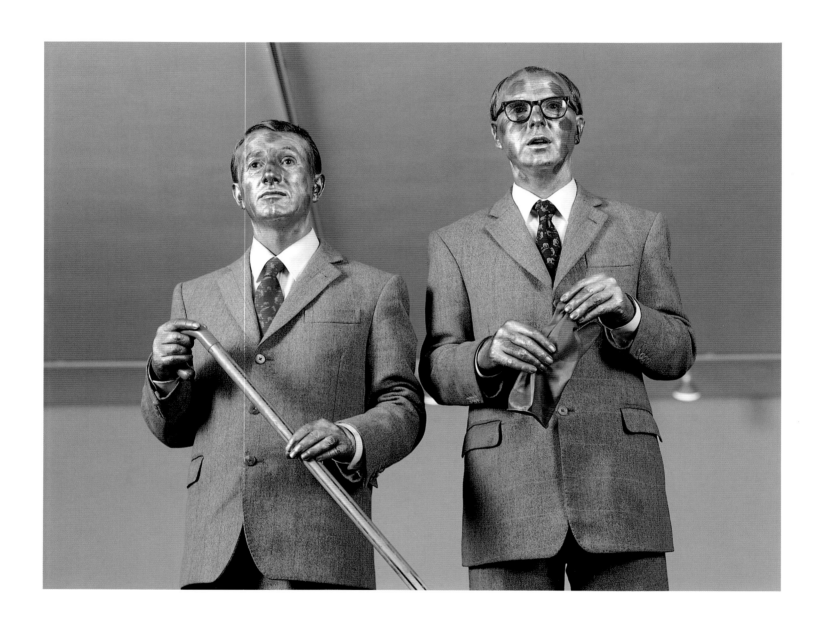

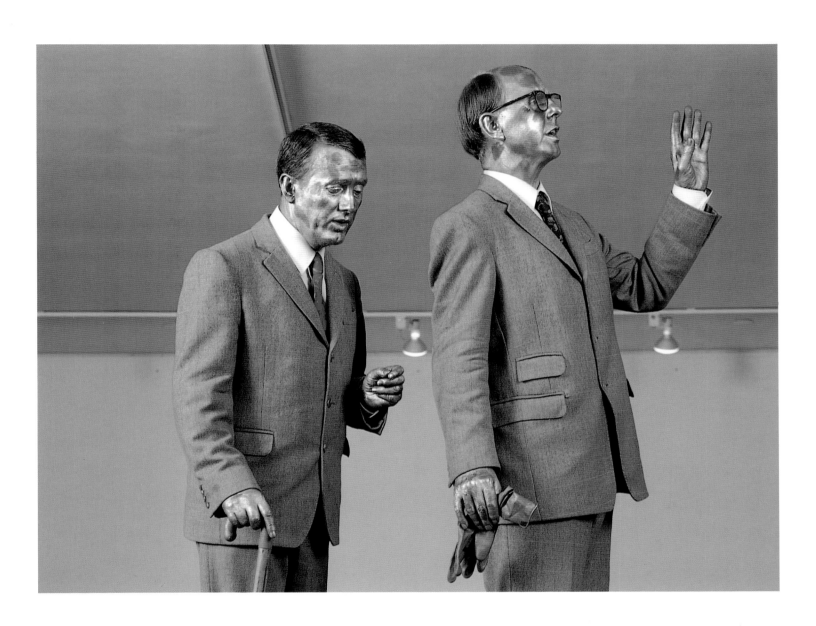

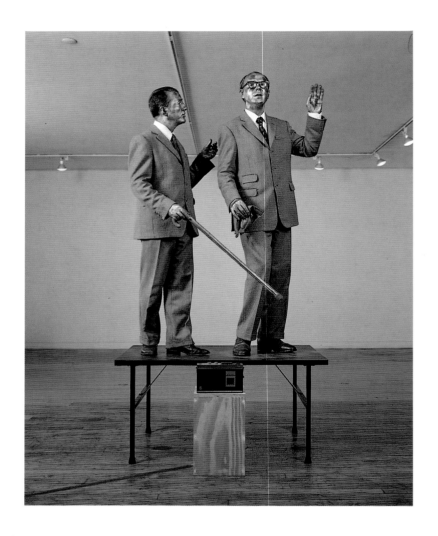
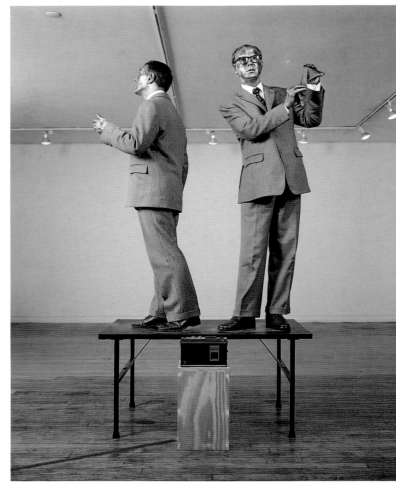

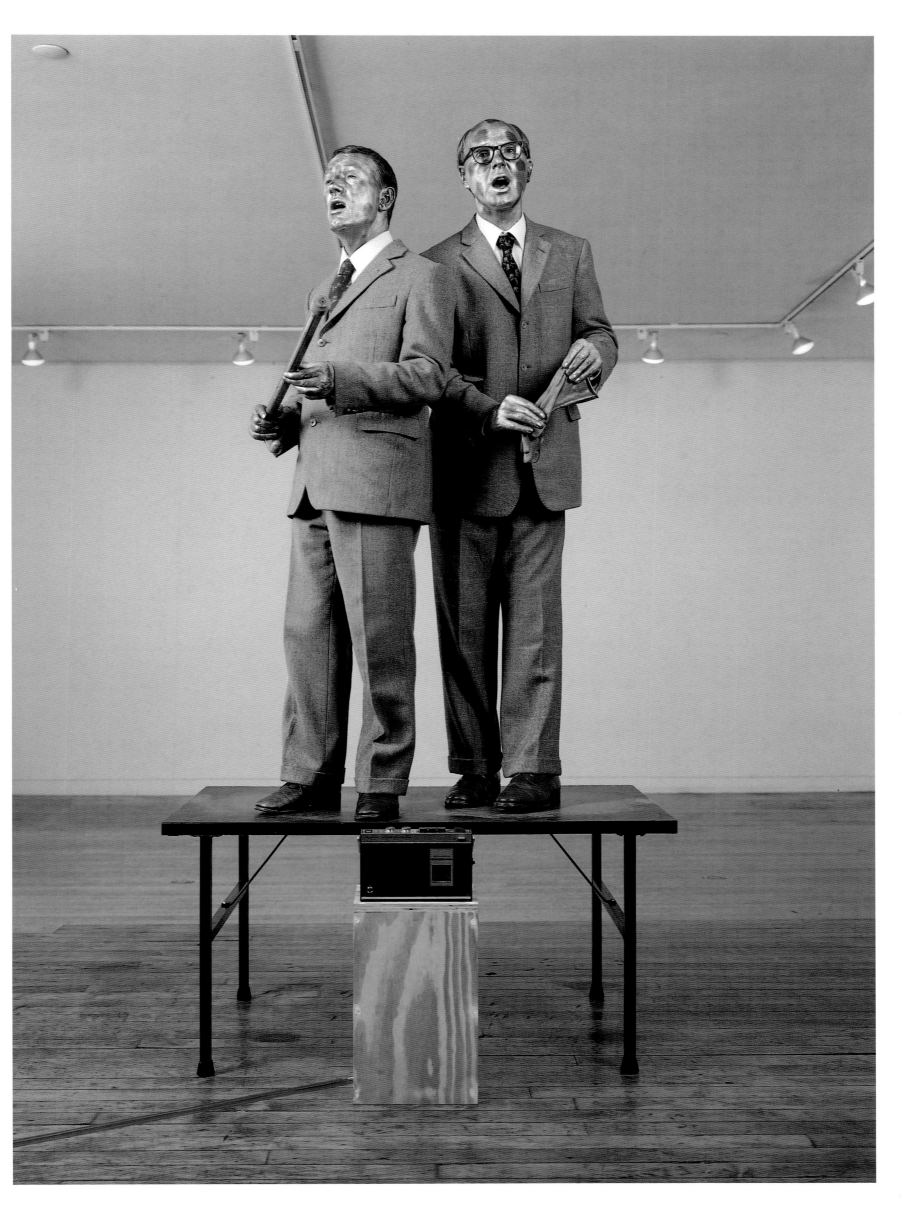

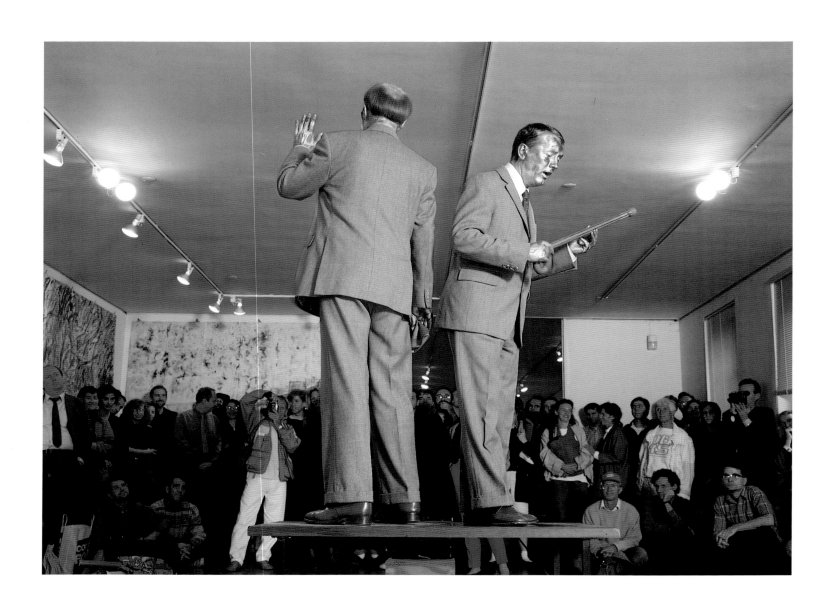

GILBERT & GEORGE:
THE FABRIC OF THEIR WORDS
CARTER RATCLIFF

When they presented *The Singing Sculpture* at the Sonnabend Gallery in September 1971, Gilbert & George inaugurated the establishment's premises on West Broadway, the main street of SoHo. Newly named, this Manhattan neighborhood had only recently become an art zone. Two decades later, in the same room and the same autumn season, the artists redid the piece, and thus marked off a stretch of time. Both Gilbert and George were thicker through the middle now. Beneath metallic makeup, their faces had settled toward maturity. These were developments noticeable only in a comparison of photographs, old and new. I saw the work presented in 1971, and detected no difference in the reprise. The changes were in the artists, not in the sculpture.

Calendar time but no clutter of experience, no lived time, separated the early and late renditions of *The Singing Sculpture*. Each was utterly fresh, as if neither could be enclosed by its moment. In 1991 as in 1971, Gilbert & George made themselves immediate by putting themselves at a distance. Ascending a table, they charged their bodies with the strangeness of automatons. Perhaps a landmark or its temporal equivalent can be effective only by holding itself somehow apart from the terrain or the time it measures off. Remember Admiral Nelson, who towers a full 170 feet above the pavement of Trafalgar Square. The first and second SoHo presentations of *The Singing Sculpture* belonged not to SoHo but to each other, like a gesture and its reflection in a glass. This eerie sameness prompted New Yorkers to recall how much SoHo had changed.

Twenty years ago, America was emerging from a season of assassinations and drifting toward Watergate and a president's resignation. The Vietnamese debacle was worsening. It was an unhappy time. Yet the New York art world felt serene, even a touch giddy, as the 1971 season began. In SoHo's fresh and bustling success, New Yorkers saw evidence that American artists and dealers

were preserving their long ascendance. That the Sonnabend Gallery chose to mark its SoHo opening with a living sculpture by Gilbert & George seemed to prove a point the New York art world never doubted: the city was a powerful magnet. Like any magnet of whatever force, it had a double polarity. Repelling most foreign art as irrelevant, it attracted the few exceptions worthy of American attention. Hour after hour, as the exceedingly foreign Gilbert & George worked their way through the repetitions of *The Singing Sculpture,* New Yorkers were entranced. They were also baffled. Though Gilbert & George looked important, no one could say why. At the center of art world power, this failing didn't seem reprehensible. Power is blithe, and tends not to linger for explanations.

Slowly, in a series of lurches, the New York art world declined. Or it might be better to say that artists and dealers gained strength in other cities—London, Rome, Frankfurt, Cologne, even Madrid. During the early 1980s, New Yorkers were suddenly agog at the work of the German and Italian painters called the Neo-Expressionists. Having ignored most European art for decades, the city now buzzed with talk of a transatlantic invasion. As the '80s went on, the New York art world realized that it formed only a single province, though an important one, on a newly drawn map. Gilbert & George's 1991 rendition of *The Singing Sculpture* at Sonnabend reminded New Yorkers of a time when their city was still the shining, undisputed capital of Western art. In those days, New York had summoned Gilbert & George imperiously. Now, the artists were returning to perform a memory-laden favor. So the event generated clouds of nostalgia. Beneath these clouds, members of the audience, not Gilbert & George, grew dim.

Throughout the 1980s, the American government proclaimed the nation's recovery from the difficulties of the previous decade. Naturally, little stress was laid on the proliferation of new problems. For example, as Reaganite images pictured America's return to stability and strength, increasing numbers of its citizens became homeless. Some in Gilbert & George's recent New York audience believed that the artists had prophesied this disaster by singing "Underneath the Arches" so many years ago. After all, this old music-hall song is the anthem of two tramps who make their beds on London's cobble-

stones. Gilbert & George, it appeared, had revealed themselves to be social commentators of remarkable prescience. This interpretation is generous but parochial and shortsighted, for the art of Gilbert & George has often reflected the moment's urban misery. Their photo-pieces of 1977–80 teem with drunks, madmen and others cast out alone, onto the pavements of London. Further, admirers went awry in supposing that Gilbert & George have ever intended their art to condemn failed social policies. When the Singing Sculptures ascend their pedestals, they never hand down indictments.

To get at what Gilbert & George meant and continue to mean by their art, it is useful to look at the work of the late Joseph Beuys. For this German visionary, too, was a foreigner who managed to make himself visible in the New York art world of the 1970s. Unlike Gilbert & George, Beuys entered the city cautiously, almost surreptitiously. At the Museum of Modern Art's "Information" show, which opened in the summer of 1970, he was represented by pictures of artifacts—his *Fat Chair* (1964) and a few "action objects" used in performances. Beuys's art was not seen again in New York until 1974, when the Ronald Feldman Gallery showed his *Noiseless Blackboard Eraser* (1974). There was another small exhibition the following year, at the John Gibson Gallery. Then, in 1979, the Solomon R. Guggenheim Museum put on an immense Beuys retrospective, and the artist finally became vivid to New Yorkers. With his fedora, vest and wrinkled pipe-stem work pants, he now stood in sharp contrast to the impeccably decked out Gilbert & George.

Beuys portrayed a wounded, ghostly creature who wanders alone amid urban monuments of the kind impersonated by Gilbert & George. At every step, he registers on his frail being the oppressive weight of his surroundings. It is the character of Pierrot, the unhappy clown kidnapped from the commedia dell'arte by Baudelaire and Verlaine, by Daumier, Cézanne and Picasso. Avant-garde poets and painters made Pierrot an emblem of the individual whose sensibility is too fine to mesh with the structures of modern life. Appalled by the vulgarity of modern manners, he recoils from the cruelty of the marketplace and bureaucracy's deadening regimentation. In him, Baudelaire and the others saw flattering images of themselves. From Pierrot's traditional melancholy they devised an acceptably alienated way to be modern.

With so many employing him as their mirror, Pierrot's appearance could not help but change. When Jules Laforgue recruited him to serve as a fin-de-siècle Hamlet, his white costume turned an Elizabethan black. He wears a gentlemanly suit, with a proper tie and possibly spats, to speak in the voice of T. S. Eliot's J. Alfred Prufrock. The Beuysian variant of Pierrot's outfit evoked both the worthy peasant and the deserving proletarian. Beuys democratized Pierrot, yet he dispensed with none of the "aristocratic" virtues built into this ready-made persona. Giving off an air of ecstatic sadness, Beuys claimed to see further and deeper than ordinary moderns. His pronouncements were strange and sibylline, and he made peculiar objects of fat and felt, wire and string and the occasional dried fish. Nonetheless, he ambled along well-worn paths to the predictable conclusion that Western civilization is so thoroughly illegitimate that only radical art can improve it.

With his manifesto *Appeal,* issued in 1978, Beuys came as close as he ever did to giving a clear picture of his visionary program. Elaborating a folksy variation on the Marxist concept of alienated labor, Beuys argued that money has become an independent self-regulating force that functions with no consideration for humanity. Work makes little sense to the workers who must perform it, so they feel frustrated and coerced. To improve the situation, we must first acknowledge that, in its sinister autonomy, modern money wields destructive power. What is to be done? Beuys's answer to that question showed him to be a radical of the most familiar and comforting kind.

According to the *Appeal,* to see the true nature of money would be to change its nature utterly. Work would be fulfilling and the marketplace fair. Equality would prevail, as Western democracies became genuinely democratic. At first it is difficult to believe that Beuys offered this program seriously. Still, I think that he did, and that his followers accepted it without irony. Since the outset of modern times, radical artists have claimed for the imagination's programs something like the force of invincible technology. Think of Blake, who presented in words and pictures an elaborate account of the New Jerusalem, a city untouched by sexual and economic oppression. He believed that, if his audience were to join him in his vision, this perfected metropolis would simply come into being. Mondrian expected heavenly cities to spring up the moment the transcendently geometric rationale for their construction was

widely understood. Yet our cities and psyches, our politics and economies, remain labyrinthine and discouragingly dark. The crucial insights of the radical imagination, it seems, are resisted.

Modern prophets, from Blake to Beuys, have found an audience chiefly on the margins of society, where they perched to formulate their outsiders' views. Over the decades, these margins have widened, for they must contain worlds of art and literature that steadily expand as their traditions of neglected prophecy grow weightier. Here the radicals offer redemption, find their offerings rejected, and carry on in condescending despair over the incorrigibility of ordinary citizens. Here stood Beuys, with his prospectus for a Free International University devoted to his visionary curriculum. This margin is also the habitat of formalist painters and critics, who claim impatiently to know that the public will escape the inanities of popular entertainment if and when the scales fall from its eyes and it learns to see the picture plane and the framing edge precisely as formalism demands. It is on this crowded margin that Gilbert & George have always refused to stand.

The premise of radical esthetics is that most sensibilities are inadequate to the lives they must lead. The only hope for an ordinary sensibility is to become extraordinary, to transform itself with the help of advanced art and literature. To Gilbert & George, all this sounds pretentious, self-serving and in need of being attacked with jokes reinforced by occasional bursts of violent indignation. They make no objections to ordinary life, for they admire those who live it. Nothing prompts them to suggest that personality, politics or the economy should be put on a radically new footing. Accepting with fervor long-established institutions, Gilbert & George want, indeed, to turn themselves into institutional presences, like buildings or the structures of bureaucracy and social class. Yet they neither expect nor wish institutions to be static.

"The true function of art," they stated in 1986, "is to bring about new understanding, progress and advancement. Every single person on Earth agrees that there is room for improvement." Never do the sculptors promulgate a detailed program. Their faith is in the individuality that will guide us all to better our lives, if only we can be awakened to whatever it is, for each of us,

that deserves betterment. They lay down no rules for others, nor do their works make pointed arguments. Yet Gilbert & George are didactic artists. They have a message, which they convey with the wide open, all-enveloping generosity of their art. Their preface to a catalogue of their works sold for the benefit of AIDS patients declares:

> In making these Pictures the forms and meanings in them brought
> us to a new understanding of the importance of the freedoms of life.
> In these pictures we provide an opportunity to think and feel a
> new openness and compassion towards the human person.

The artists would like, with all their oddness, to fit in, and to bring light.

Seeking to improve the world, Gilbert & George celebrate it, and their celebrations employ the forms of history and tradition that the world employs in shaping itself. So they wear proper suits and impersonate statues. They use the familiar devices of commercial photography, graphic design and films. Indifferent to Old Master paintings, Gilbert & George like the new, yet they have no interest in the stylishness that passes itself off as progress. They love the inertia of the modern world and its substantiality. That is why their suits are a bit old-fashioned, in fabric and cut. The statues they impersonate are of the kind that municipalities hardly ever install anymore. There are echoes of wartime posters in their large pictures of the 1980s, and they have made pieces out of postcards published in the Edwardian period. For Gilbert & George, the living present is an expanse of nearly a century. One feels its weight, its density, in all that they make visible, and one can sense the immensity of this present in the language of their art.

"Happy when daylight comes creeping heralding the dawn"— these phrases were well worn by the time they appeared in the lyrics of "Underneath the Arches." The flaunting of that shabbiness was part of the joke. The song's lovelier flourishes had undergone a social migration, from the realm of genteel poetry to the music-hall stage. That was another part of the joke, beyond which lurks a stolid dignity. "Underneath the Arches" shows language in a weathered, heavily patinated state—a monumental state. Like the bronze statuary we see (or overlook) in the modern city, the words of "Underneath

the Arches" belong to modern times yet never seem to have been new. So it was fitting to hear those worn-out words emanating from bronze-colored heads at the Sonnabend Gallery twenty years ago. Away from the gallery, when the presentation was over, Gilbert & George's most casual bits of chitchat fit just as neatly with their statuesque condition.

One afternoon, during their first visit to New York, Phyllis Derfner and I took a voyage with Gilbert & George on a Circle Line boat. Like the Statue of Liberty, the Circle Line cruise around the island of Manhattan is an institution of interest chiefly to tourists. Thus it was a proper diversion for Gilbert & George, who counted as visiting institutions. The artist Les Levine came along on the outing, as did critics Peter Schjeldahl and Arlene Laddin. Crisp and brilliant, the light of that September afternoon threw Gilbert & George into sharp focus as they stood on the deck in sculptural poses. The skyline was their backdrop, measured off by landmarks like the Empire State Building and the headquarters of the United Nations. It wasn't easy to know if one should point out less well known features of the skyline, but we did.

"That's the 52nd Street pier," somebody would say to Gilbert or to George, and blankly, calmly, he would reply, "Oh, yes, wonderful," or "Marvelous," or "Super." "Would you like anything to drink?" someone else might ask. "No, thanks awfully," was the answer, or "Yes, please. How terribly kind." Then, "It's a nice day, isn't it?" "Oh, yes, absolutely splendid." Gilbert & George employed conversational forms they had found ready-made, like the lyrics of "Underneath the Arches." Yet they directed no Duchampian condescension toward these verbal objets trouvés. Their refusal to be ironic was militant. Describing the weather or the view as "absolutely splendid," they were as utterly earnest in their tenth as in their first use of the phrase. Gilbert & George did not so much converse as offer rigid, impersonal, thus monumental, representations of what proper conversation should be. At Sonnabend, they had sung as Singing Sculptures ought to sing. Now they were talking as Living Sculptures (another of their self-applied labels) ought to talk.

At first, I saw a disparity between their obsession with the niceties of deportment and their dedication to large themes of life and death, of home and homelessness. That was an error. Gilbert & George make art from the entire

fabric of the life they know. Each thread is as important as every other. In their eyes, it all unravels if manners fail.

Over the years, Phyllis and I saw them often, in London and New York. We heard their conversation grow more flexible and friendly, but never did it become less impersonal. Always, whether teasing or reminiscing or proclaiming again their devotion to "Western Democracy," Gilbert & George continued to speak as if from an official position. Much changed, in their talk and in their art, but this statuesque attitude did not. They remained dedicated to a monumental notion of propriety that links personal behavior to the largest structures of the culture—its architecture of belief and value. To act properly is to aspire to the probity of a familiar landmark, a presence that defines the surrounding terrain. Even when they joke, Gilbert & George let it be known that, for them, to behave well is to be morally good. The question of superficial decorum hiding dubious intentions does not arise, because they are the Living Sculptures. Their surface is their essence, their essence their surface.

Conversing with Gilbert and George, one eventually understands that they could not have become the Living Sculptures if they had not been singing, talking, reciting Sculptures. Language, no less than sculpture, painting and drawing, no less than photography, is the medium of their art. Even in 1971, when their talk was so rigid, their language had nonetheless been rich and flexible, not in conversation but on the printed page.

An echo of their early chitchat appears in the prim tone of the invitations they distributed at the outset of their career. One of these, for a presentation of *The Singing Sculpture* in 1969, reads: "We would very much like you to be present at 3 pm on 26th October when we present the above piece in the most naturalistic form." This is language pro forma. Gilbert & George took guidance from another set of forms—those of the generic diary entry—as they wrote the caption for an early, untitled "postal sculpture":

> The last Saturday in November of '69 we had just made some cocoa
> when it began to snow so we positioned ourselves at the window
> as we began to look we felt ourselves taken into a sculpture of over-
> whelming purity life and peace a rare and new art-piece we thank
> you for being with us for these few moments.

A Guide to
Singing Sculpture
by
GEORGE & GILBERT
the human sculptors

1970
'Art for All,' 12 Fournier Street, London, E.1, England
Tel. 01 247 0161

The
most beautiful
moving, original,
fascinating and serious
art-piece you have ever
seen. It consists of
two sculptors, one
stick, one glove
and one
song.

SIX POINTS
towards a better understanding

Essentially a sculpture
we carve our desires in the air.

Together with you this sculpture presents
as much contact for experiencing as is possible.

Human sculpture
makes available every feeling you can think of.

It is significant that this sculpture
is able to sing its message with words and music.

The sculptors, in their sculpture,
are given over to feeling the life of the world of art.

It is intended that this sculpture brings to us all a more light
generous and general art feeling.

SCULPTING WORDS

The Ritz we never sigh for, occasionally we have a drink there, *the Carlton they can keep, there's only one place that we know and that is where we sleep. Underneath the arches* is still our most important realistic abstract wording. It lives along with us as we dream our dreams away realising how few people have had thoughts on these our sculpture words for we are really working at dreaming our dreams away. *Underneath the arches on cobblestones we lay* is increasingly our position as day after day we rest on these our cobblestones. *Every night you'll find us tired out and worn* for after a day of sculpting we are sometimes a little tired. *Waiting till the day-light comes creeping heralding the dawn* of another day of light in which to find our sculpture way throughout that time. *Sleeping when its raining and waking when its fine,* its all the same to us and it doesn't matter where we are or what we are doing as long as we sculpt along our way. *Trains travelling by above* as everything goes along leaving us here. *Pavement is our pillow,* but then whats wrong with that, *no matter where we stray,* we are there with our all. *Underneath the arches we dream our dreams away.*

A pamphlet published by Gilbert & George in 1970, under their imprint
Art for All, for the audience of their *Singing Sculpture* presentations

Here, the recital of mundane events leads to a reflection on large spiritual matters, a personal testimony of the kind made institutional by dissenting Protestant sects. One kind of found language becomes another. Gilbert & George ease shifts like these by seeing everything at a distance, as monumental sculpture. In long perspective, transformations go smoothly.

As it grows calm, ecstatic testimony turns homiletic. Hence, Gilbert & George's tract *The Laws of Sculptors* (1969). The first dictum is a word to the wise about one's social presence: "Always be smartly dressed, well groomed relaxed friendly polite and in complete control." The third is "Never worry assess discuss or criticize but remain quiet respectful and calm." These laws touch on the practical side of being sculptural. In the tone of a proverb, the final one gets at the spiritual point of the effort: "The lord chissels still, so dont leave your bench for long." Addressing all that is ordinary and generic in every self, proverbial language sounds like the conversation of a garrulous stranger—impersonal yet intimate. Those traits are mixed in another way by the language of the limerick, which appeared in a "postal sculpture" Gilbert & George sent to friends and others in 1971.

To accompany ink drawings of themselves in transit and at rest, they wrote, for example:

> There were two young men who did laugh
> They laughed at the people's unrest
>
> They stuck their sticks in the air
> And turned them around with the best
>
> Then with time they began to feel strange
> For no longer it swung in their way
>
> So to capture again that old thrill
> They started to take the life-pill

Displaying the expected meter but not the correct stanzaic form, these verses are not, strictly speaking, limericks. Nor are Gilbert & George's properly worded invitations properly punctuated. Often, in the early days, their spelling and punctuation were lax. Most glaringly of all, they are flesh and

WHAT OUR ART MEANS

ART FOR ALL

We want Our Art to speak across the barriers of knowledge directly to People about their Life and not about their knowledge of art. The 20th century has been cursed with an art that cannot be understood. The decadent artists stand for themselves and their chosen few, laughing at and dismissing the normal outsider. We say that puzzling, obscure and form-obsessed art is decadent and a cruel denial of the Life of People.

PROGRESS THROUGH FRIENDSHIP

Our Art is the friendship formed between the viewer and our pictures. Each picture speaks of a 'Particular View' which the viewer may consider in the light of his own life. The true function of Art is to bring about new understanding, progress and advancement. Every single person on Earth agrees that there is room for improvement.

LANGUAGE FOR MEANING

We invented and we are constantly developing our own visual language. We want the most accessible modern form with which to create the most modern speaking visual pictures of our time. The art-material must be subservient to the meaning and purpose of the picture. Our reason for making pictures is to change people and not to congratulate them on being how they are.

THE LIFE FORCES

True Art comes from three main life-forces. They are:–

THE HEAD
THE SOUL
and THE SEX

In our life these forces are shaking and moving themselves into everchanging different arrangements. Each one of our pictures is a frozen representation of one of these 'arrangements.'

THE WHOLE

When a human-being gets up in the morning and decides what to do and where to go he is finding his reason or excuse to continue living. We as artists have only that to do. We want to learn to respect and honour the 'whole.' The content of mankind is our subject and our inspiration. We stand each day for good traditions and necessary changes. We want to find and accept all the good and bad in ourselves. Civilisation has always depended for advancement on the 'giving person.' We want to spill our blood, brains and seed in our life-search for new meanings and purpose to give to life.

Gilbert & George
1986

A statement from the invitation to the private viewing of Gilbert & George's
"Pictures 1982–86" at the Hayward Gallery, London, 1986

blood and so cannot, with propriety, claim to be sculptures. Or so it is possible to object.

The obvious reply is that of course they are not sculptures as a bronze Nelson is a sculpture. In claiming to be sculptural, they hope to enlarge the ordinary sense of the word. With their art, Gilbert & George shift and expand the meaning of words and images. Yet they are not avant-gardists intent on overturning the world's familiar order. Gilbert & George want to reveal what is good about that order, and to strengthen it. So they are proper in ways calculated to startle a breath of life into ideas of propriety that we have permitted to become boring. Their way of being diaristic illuminates the allure of daily life, and their proverbial tone turns clichés into monuments— some of them gleaming, others smudged. Since the mid-1970s, the realism of their art has put on display the pensive, ecstatic, nightmarish strangeness of ordinary reality.

A few years ago, they had a New York show of Twenty-five Worlds, a series of postcard sculptures. Each is made of bright, shiny, Kodachrome postcards freshly plucked from the rack and arranged in neatly concentric patterns. Their early works in this genre present old postcards in irregular patterns. In a piece on the theme of drunkenness, there is a postcard picturing seven overflowing glasses of ale. It tells in its caption of putting "in a full week here." Another shows a drunk staggering along a street where the pavements and the buildings, too, are tipsy. "Heaven help the sailors on a night like this!" reads the motto.

Soaked in this anonymous jocularity, Gilbert & George began producing it themselves. For the postal sculpture called *Pink Elephants* (1973) they composed this burst of fatuous chatter:

> Had two dizzy spells
> at lunch today.
> Asked the two identical waiters
> to bring us a couple of doubles
> for the second time.
> Felt twice as good.

And, among several other passages:

> Nice beano last night.
> Awoke this morning
> Feeling absolutely marvelous
> Must be some road
> Repairs going on nearby as
> there is this terrible sound
> of drilling.

This is the voice of a Wodehousean twit who cannot distinguish his hangover from the noise of roadworks. By affecting this tone, Gilbert & George added the vast realm of silliness to their world.

In 1974 Gilbert & George let the fizz of their inebriation collapse into the gloom that dragged them through the horrors of Human Bondage (1974) and Dark Shadow (1974). From these and other series of photo-pieces made in the mid-1970s, the artists extracted images and gathered them into a book, also called *Dark Shadow* (1974). Filling a page, each image faces a block of text of precisely the same size. Words and images strike a balance, but not a comforting one. In a detached but insistent tone, the voice of the text comments on the picture opposite. Of cabinetwork in the sculptors' Fournier Street house, it says: "Rectangular hinges and lines." The trouble is that it cannot confine itself to simple description of palpable facts.

Of another portion of another room, the voice remarks: "Darkish corner of homely sadness." Of still another: "Here is the entire heavy reality of the balance of dark shadow and paneling. This is a sample map and gazetteer of our shadowy intellects. We can hardly bear to look upon this misleading accurate clear confusing picture." Objects, like Gilbert & George, the only two people present, are immobilized in frantic states of being. The voice says of a picture of Gilbert printed upside down:

> Falling in with figure carrying its own value of light in this depressing
> atmosphere. Eyes stretched out toward feet completing the figure in
> a glance of horror. Head promising to crash with the heaviness melting
> into the whole awareness....

Seeking the resting point of a solid conclusion about appearances, the voice endlessly, knowingly, fails. Its driven meandering has a resemblance to art criticism, though the critics—Gilbert & George—are among the works criticized. As the calm and unstoppable voice of *Dark Shadow* persists, the pressure of its analysis leaves perspectives increasingly skewed. It is here that Gilbert & George's language started to sound demented. To silliness they had annexed madness.

Because no books followed *Dark Shadow,* many in Gilbert & George's audience assumed that their language now flowed plentifully only in conversation. This was a forgivable error: so much of what they said was recorded and published in interviews. Much more—their talk at gallery openings, at parties and at table—was lost. Yet none of that public verbiage was pointless, for Gilbert & George may chatter, but never idly. In public, they advanced their grand themes of love and hope and tradition. In the studio, the sculptors seemed content to let pictures drift free of language.

Yet they often built words into the structure of those works, one letter to a panel: "C-U-N-T" or "F-U-C-K" (both 1977). Sometimes they found and photographed entire phrases: "Are You Angry or Are You Boring?" (also 1977). Gilbert & George's photo-pieces of 1978 included *Morning, Evening, The Building,* and *The Alcoholic.* As the 1980s began, the artists colored this descriptiveness with bright, difficult emotion. Under the heading of Modern Fears (1980–81) appeared works entitled *Living with Fear, Living with Madness, Night Monster,* and *Burning Souls.* In 1982 the frenzy of *Cabbage Worship* led to the calm *Winter Flowers.* Then, through the amazing number and variety of that year's photo-pieces they came to the 36-foot-wide picture *Life Without End.*

Him, Me, Light (all 1985) recall "Us," "Day Break," "Dawn," words used to caption photos of Gilbert & George in the role of tramps. The words are from "Underneath the Arches." The images appear in *Side by Side,* the artists' first book, published in 1971. At the beginning of their career, when their texts were long and elaborate, they already knew how to give a word the weight it needs to balance a statuesque image. And later, when the titles of their works made their command of verbal fragments obvious, they still, on occasion,

Running dry and dusty with the progress
through the stench and clumsy rubble
of the course. The light at the window
burns still and lights the dark of gloomy
hollow eye. The features pressing for-
ward straining in past hopes to capture
the darkness ahead and then to wrap
about oneself the magic substance like
a dark cream, protective, warm, nourish-
ing and so casual in the modern sense
of the persons responsibility of being
with the other peoples. That care
is all ours to fully amuse ourselves.

61

STENCH and PROGRESS

The two reclining figures roll and turn
slowly as if roasting on a spit. They
make suitable cooking noises and then
sometimes there is a collision or a
turning over of bottles. Clear pure
strong alcohol laps heavily on the shore
of this picture's meaning. A glass is
carelessly filled, carefully emptied, care-
fully refilled and then carelessly emptied.
The suits remould themselves with each
movement into stranger more valuable
sculptures. The black shadow has
come over the heads and bottles and all.

114

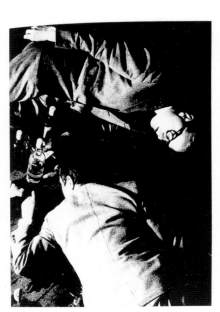

DRUNKEN FIGURES

Two spreads from Gilbert & George's 136-page clothbound book *Dark Shadow,*
published in an edition of 2,000 in 1974 under their imprint Art for All

wrote extensive and densely layered texts, as witness the narrative they composed for *The World of Gilbert & George,* a film written and directed by them, produced by Philip Haas and released in 1981.

Near the start of the film, the camera looks through the windows of the sculptors' study, as they say:

> Misery for all. Here the struggled punished nature masks the hands of man's three hundred years of crude loving desperate commerce. Death/life, no youth, death/life. No friends, no feeling for our order. The only human being trees are close to us in moving leaves and ways. They are the only real friends that we have.

As it goes on, this sad commentary returns memory to the days of drunkenness and *Dark Shadow*—the book and the series of photo-pieces. Then as later, gloom compacts language and yet drives it forward, with heavy sinuosity, to regions just beyond sense: "Eyes ache to wrench out true meant good safe true story." The sculptors' language is entrapping itself.

Release comes through images of Gilbert & George at prayer. The camera moves to ecclesiastical subjects, both sculptural and architectural. Next we see the London skyline and the evening sky, and we hear Gilbert & George reciting the Lord's Prayer. This is found language, and soon there is more of it, this time taken from seed packets. As flowers and youths' faces alternate on the screen, the artists note that the Creeping Buttercup is "a short to medium hairy creeping perennial with rooting runners and leaves rather triangular in outline with stalked end lobes. Sepal erect and flower stalks not furrowed," and so on. Three other blooms are described in this professional gardener's idiom.

As the film continues, this and other varieties of language reappear, until the screen shows the sculptors' faces floating in gloomy shadow. Then the sound track is flooded by a desperate scream. A flurry of images follows, but not many words. At the finish, nearly, bells begin to chime. We see Gilbert & George sitting. The camera moves in on their faces and they say:

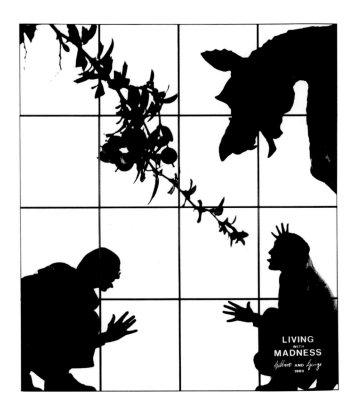

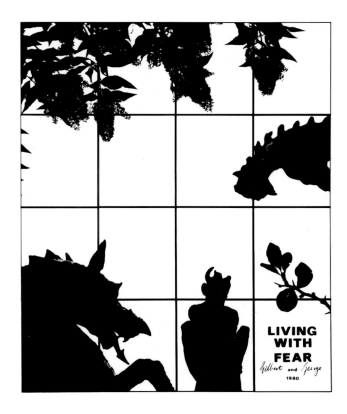

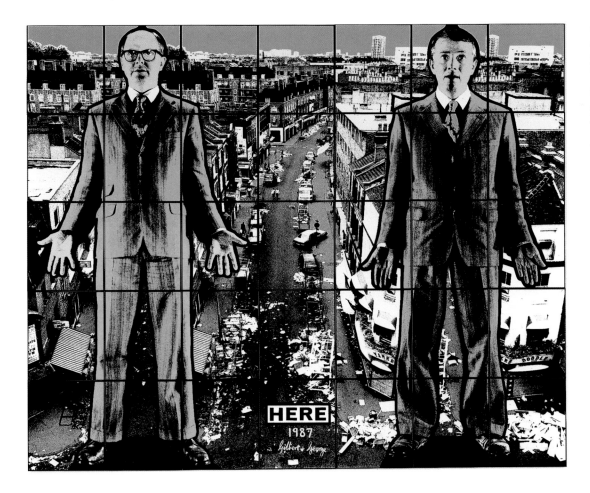

Gilbert & George,
Living with Madness and
Living with Fear, 1980.
Both 241 x 201 cm

Gilbert & George,
Here, 1987.
302 x 351 cm

This is the world
This is our end
This is our world
And this is the end.

They mean, I think, the end of the film but not of the world. For Gilbert & George, it is never the end of the world, no matter how sad they become. They have defined the world as their world, which they understand as their end, their continuing purpose: in celebrating what is, they found the point of their existence. They find a reason to carry on, for surely this verse about worlds and ends is to remind us of the "world without end" in *The Book of Common Prayer*. We're helped here by photo-pieces with titles like *Power and Glory* (1980) and, of course, *Life Without End* (1982).

In 1978 Gilbert & George announced:

> We believe in the Art, the Beauty, and the Life of the Artist who is an eccentric Person with something to say for Himself. We uphold Traditional Values with our love of Victory, Kindness and Honesty. We are fascinated by the richness of the fabric of Our World and we honor the High-Mindedness of Man as the ultimate Form and Meaning of Art. Beauty is Our Art.

The sculptors included this proclamation in *The World of Gilbert & George*. Soon they had issued another one, in answer to the question, "What Is a Post Card Piece?"

> The form of the Post Card lends itself to the expression of finer feelings, stirring thoughts and beautiful views....

Earnest and stilted, these statements are believable, but not as anything anyone would say. One hears in this language the tone of an institution.

On their earliest publications Gilbert & George sometimes printed the Royal Seal, for they like the aura of all that is official. Authority as presently consti-

tuted is not always congenial, yet they relish its look and the ring of its voice. So the statements of general belief which Gilbert & George began issuing in 1978 sound like communiqués from a Ministry of Proper Sentiments. In talking of "Victory, Kindness and Honesty," or of "finer feelings, stirring thoughts," they speak not as individuals but as representatives of the institution called Gilbert & George. That they are, after all, individuals named Gilbert and George is, by now, a familiar complication.

The depth of our familiarity with the puzzles of their art was evident when they redid *The Singing Sculpture* at the Sonnabend Gallery. Then, as twenty years before, the audience wondered whose unhappy feelings were being conveyed, whose wistful dreams were being dreamed away. For the artists, in firm command of the moment and of memory, were not sad cases. They were only impersonating sad cases, yet they too are sad, sometimes. As the Singing Sculptures, they shift their sadness onto the figures of singing tramps. Onto the figures of neatly dressed, metal-headed automatons, they shift their relentless dedication to their art. Theirs is an art of slippage, of meanings, images and even forms of grammar displaced. The original displacement of metallic qualities made statues of their bodies. Other transformations followed. Pictures, language and the world became sculptural, which is to say, monumentally significant. The art of Gilbert & George is a method for making everything mean what it usually does, only with grander, more vivid force. It is a method designed to justify a hope: if we can only be induced to see how things are, maybe we will, after all, make the improvements that Gilbert & George have been desperately waiting to see.

PHOTOGRAPHS, STATEMENTS, DOCUMENTS, REVIEWS
1969–1973

'Our New Sculpture'

may be viewed

at the Camberwell School of Art, Room 26, Main Building

Monday, 27th January, 1969, at 6.30 pm

We will be honoured by your presence

Gilbert. George

Our New Sculpture was presented at St. Martin's School of Art on January 20, 1969, at the Royal College of Art on January 23, and at Camberwell School of Art on January 27, with similar invitations printed for each presentation. *The Singing Sculpture* "was made initially as just *Our New Sculpture* and presented as a piece of sculpture at various schools of art. We just played the record twice, on one side. It was turned twice to give the illusion we were turning the record, which wasn't true. And there was a short speech before and a short speech after" (Gilbert & George, from an interview with Anne Seymour in *The New Art,* Hayward Gallery, London, 1972).

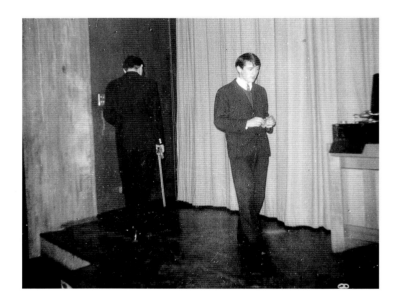

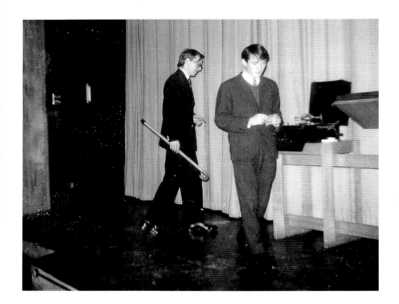

THE LAWS OF SCULPTORS

1 Always be smartly dressed, well groomed relaxed friendly polite and in complete control
2 Make the world to believe in you and to pay heavily for this privilege
3 Never worry assess discuss or criticize but remain quiet respectful and calm
4 The lord chissels still, so dont leave your bench for long

One of two texts written to accompany the
SHIT AND CUNT Magazine Sculpture, 1969

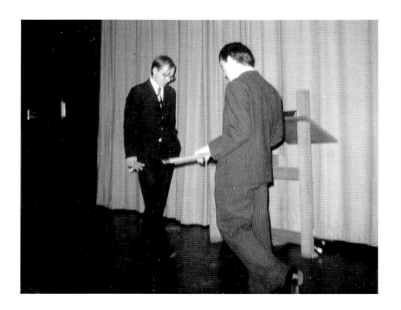

Our New Sculpture at the Royal College of Art, January 23, 1969

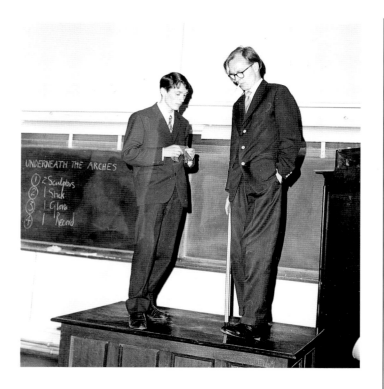

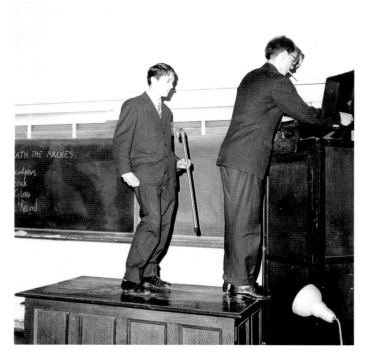

GILBERT and GEORGE

THE SCULPTORS

PRESENT

'UNDERNEATH THE ARCHES'

(The most intelligent, fascinating, serious and beautiful art piece you have ever seen)

College *Slade School of Fine Art*
Place *Weldon Theatre*
Time *3pm*
Date *4th. June Wednesday.*

GILBERT AND GEORGE
Caroline Tisdall

WE WOULD HONESTLY LIKE
TO SAY HOW HAPPY WE ARE TO
BE SCULPTORS.

"O Art, what are you? You
are so strong and powerful,
so beautiful and moving. You
make us walk around and
around, pacing the city at all
hours, in and out of our
Art for All room. We really do
love you and we really do
hate you. Why do you have so
many faces and voices? You
make us thirst for you and
then to run from you escap-
ing completely into a normal
life: getting up, having break-
fast, going to the workshop
and being sure of putting our
mind and energy into the
making of a door or maybe
a simple table and chair. The
whole life would surely be
so easeful, so drunk with the
normality of work and the
simple pleasures of loving
and hanging around for our
lifetime. O Art where did you
come from, who mothered
such a strange being. For
what kind of people are you:
are you for the feeble of
mind, are you for the poor-at-
heart, are you for those with
no soul. Are you a branch
of nature's fantastic or are
you an invention of some am-
bitious man. Do you come
from a long line of arts?
For every artist is born in the
usual way and we have never
seen a young artist. Is to be-
come an artist to be reborn,
or is it a condition of life?"

This is an extract from Gil-
bert and George's booklet
"To be with Art is all we ask."
They regard it as an expres-
sion of their attitude to art
and life which for them are
one and the same thing. The
booklet itself is one of their
art forms.

< *Underneath the Arches* at the
Slade School of Fine Art,
June 4, 1969

Gilbert, an Italian, and
George, a Devon man, met as
students at St Martin's, and
their earliest works together
were in resin. When they left
the college they also "left
their little studio with all the
tools and brushes, taking
with them only some music,
gentle smiles on their faces
and the most serious inten-
tions in the world." They
embarked on a year of private
activity, setting up their office
in Fournier Street under the
name of "Art for All."

The year's activity included
performances in all the major
London art colleges, in the
course of which they moved
as if dancing to the song
which they have made their
own: "Underneath the
Arches," luring students in
with sweets, cigarettes and
tapes playing in the corri-
dors. At the same time they
started their "Art through
the Post" messages of cheer-
ful nature for people to open
at breakfast, and visits to
strangers in the art world.
A high point of the year was
a Sunday afternoon perfor-
mance in the Geffrye Mu-
seum entitled "Reading from
a Stick," attended by all the
dignitaries of the borough of
Hackney. One hundred and
eighty slides of one-inch
areas of Gilbert's resin walk-
ing stick were shown. It was
the greatest turn out they
have ever had.

A turning point came earlier
this year when they sent
out their "Message from
the sculptors Gilbert and
George." This contained
"sculptor's samples"—
fragments from their life—
and listed their range of
sculpture—"singing sculp-
ture, interview sculpture,
dancing sculpture, meal
sculpture, walking sculpture,
nerve sculpture, cafe sculp-
ture, and philosophy sculp-
ture." The message finished:
"So do contact us." Many
people did, and shortly
afterwards they gave an anni-
versary performance of
"Underneath the Arches"
in Cable Street.

The London art world was invited to "view the most beautiful, fascinating, dusty, realistic and naturalistic art piece bringing to you a clear picture of avant-garde art today." Naturally many of them turned up. Then they set off to perform their "Singing Sculpture" in many of the major European and Scandinavian museums and art galleries, on their own or as part of exhibitions of the work of other conceptual artists. Since they could not be in all places at all times they evolved drawings as descriptive works. These are very large, almost life size, so that they act as pieces out of life, or explaining works.

The "Singing Sculpture" to "Underneath the Arches," which they regard as autobi- ographical, was performed for five consecutive days at Nigel Greenwood's gallery. For seven hours running, Gilbert and George sang and moved on a small table, their faces and hands painted like bronze, with a walking stick and glove. They published "Six points towards a better understanding" to explain the piece. "Essentially a sculpture we carve our de- sires in the air. Together with you this sculpture presents as much contact for experi- encing as is possible. Human sculpture makes available every feeling you can think of. It is significant that this sculpture is able to sing its message with words and music. The sculptors, in their sculpture, are given over to feeling the life of the world of art. It is intended that this sculpture brings to us all a more light, generous, and general art feeling."

Now all this may strike you as precious. I can only assure you that seeing them perform was a riveting experience. It really did make you think not only about the nature of sculpture, or of any art activ- ity, but also about the nature of life. There were cynical observers who after leaving found themselves unable to forget that they were still performing, and had to re- turn. Some people's working week was completely dis- rupted. Children were trans- fixed by it. It appealed not only to the eye and feelings, but also to everyone's inbuilt time sense.

As Gilbert and George say, "It is important for new sculptors to come to terms with the modern limitations of sculpture, apparent only through the feeling of the eye. With the tears streaming down our faces we appeal to you to rejoice in the life of the world of art."

The Guardian (London),
November 20, 1970

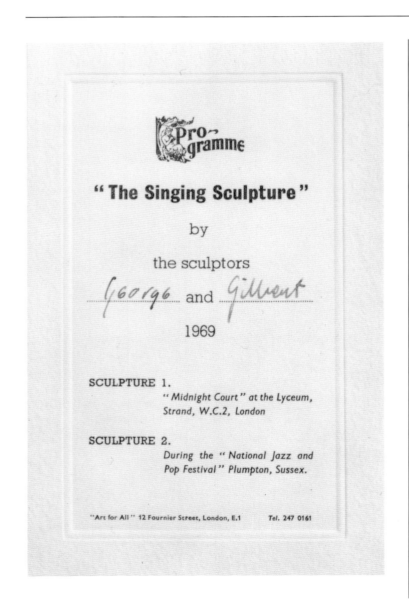

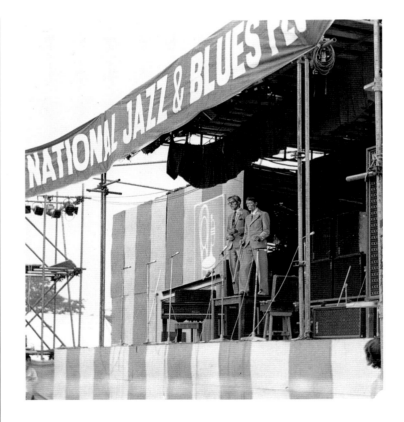

Two appearances in the summer of 1969 before rock and roll audiences, one at the Lyceum Ballroom in London, the other at the National Jazz and Blues Festival in Plumpton, Sussex, led Gilbert & George to conclude that this was not the appropriate context for their work. "It's very nice to be with the galleries, they take over splendidly," they said in an interview with Anne Seymour (*The New Art,* Hayward Gallery, London, 1972).

Anniversary

'UNDERNEATH THE ARCHES'

(The most fascinating, realistic, beautiful, dusty and serious art piece you have ever seen)

We would very much like you to be present at ⟶3 pm⟶ on ⟶26th⟶ October when we present the above piece in the most naturalistic form, revealing to you a clear picture of avant garde art. Heading East from the Tower of London along Royal Mint Street brings you to Cable Street where we have chosen Railway Arch No. 8 for the historical occasion of our anniversary of 'Underneath the Arches'.

RSVP 'ART FOR ALL', 12 FOURNIER STREET, LONDON, E.1 Tel. 247 0161

"We have this title 'Art for All' which we've always been very interested in and it has different meanings for us all the time. That's all we do really—re-form our understanding of that sentence" (Gilbert & George, from an interview with Anne Seymour in *The New Art,* Hayward Gallery, London, 1972).

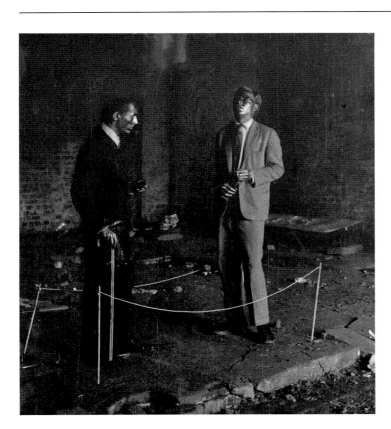

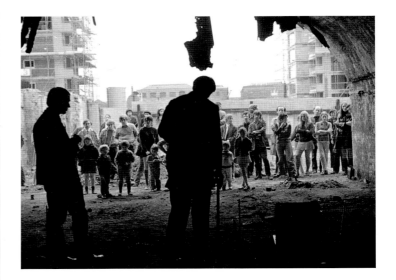

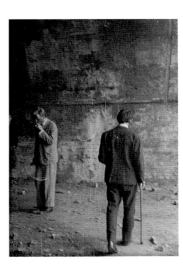

The anniversary of *Underneath the Arches,* underneath the arches in Cable Street, London, on October 26, 1969, celebrating the developing and perfecting of the piece at Gilbert & George's studio in Wilkes Street in October 1968. "When we arrived we found two tramps were already there," Gilbert & George remembered. "They didn't pay any attention to us at all, nor to the few people who came to watch us. We thought that was wizard" (quoted by Francis Wyndham in *The Sunday Times Magazine,* London, January 10, 1971).

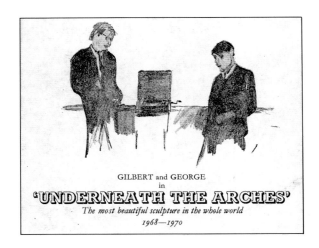

GILBERT and GEORGE
in
'UNDERNEATH THE ARCHES'
The most beautiful sculpture in the whole world
1968—1970

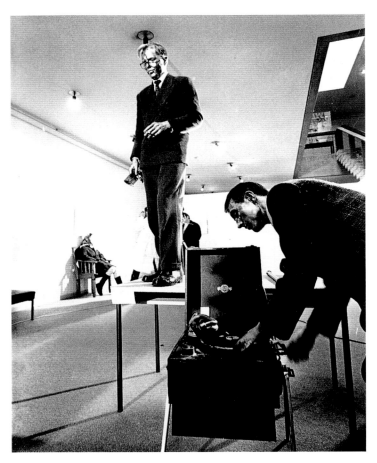

Art love to Germany

from

George + Gilbert

The Ritz we never sigh for
The Carlton they can keep
There's only one place that we know
And that is where we sleep
Underneath the Arches we dream our dreams away
Underneath the Arches on cobblestones we lay
Every night you'll find us
tired out and worn waiting 'til the day break
comes creeping heralding the dawn
Sleeping when its raining and
Sleeping when its fine
We hear trains rattling by above
Pavement is our pillow no matter where we stray
Underneath the Arches we dream our dreams away

Underneath the Arches at the Kunsthalle Düsseldorf. This was the first in a series of appearances in galleries and Kunstvereins across Europe throughout 1970. A souvenir leaflet (above) and, later, copies of Gilbert & George's pamphlet *A Guide to Singing Sculpture* (see page 37), published in mid-year, were handed out to members of the audience.

PRESENTING GILBERT & GEORGE, THE LIVING SCULPTURES
Barbara Reise

In all their physical meetings and mailers, the audience is part of the material and scale of each work. One epitome of this is...the double 1969 "Singing Sculpture" presented *inside* (the London Lyceum) at a Rock concert of enormous decibels and 1,500 packed teenagers, and outside in a Sussex Pop Festival among groups like The Who and 20,000 sprawling youth; the contrast of these crowds with the two business-suited metallic-headed figures shuffling robot-like in the spotlight was as important as the audial difference between the Sounds of the 'Seventies [and] the hand-wound victrola strains of the 1920s gently sad and nostalgic vaudeville ballad "Underneath the Arches."

"Underneath the Arches" is a piece which Gilbert & George have repeatedly described as consisting of "two sculptors, one stick, one glove and one song"—and, in their verbal 1970 *Guide to Singing Sculpture* as "still our most important realistic abstract wording....It lives along with us as we dream our dreams away...." The words to the song by Flanagan and Allen are like found objects, and important generally to Gilbert & George who also used them for their posted parched-paper broadsheet *The Sadness in Our Art* in July 1970. The glove and stick, traditional accouterments of vaudeville teams, are specifically awful and funny in their selection: the glove a pseudo-human rubber and the walking-stick a garish toy-like squeaker used to punctuate the music with regular indeterminacy. In the occasions performed, the scratched tinny-sounding song sung by Hardy and Hudson carves sentiment in the air while Gilbert &

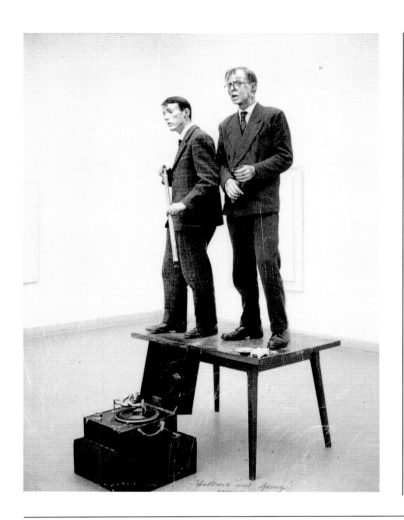

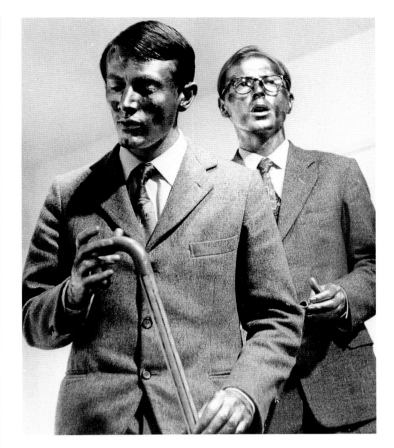

< *The Singing Sculpture* at the
Kunstverein, Hannover, in 1970

The Singing Sculpture at the
Kunstverein, Krefeld, in 1970

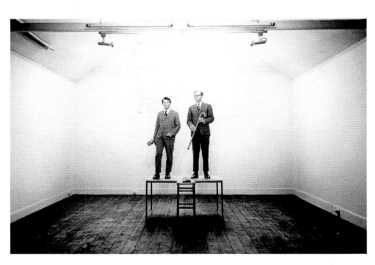

George nerve-consciously
carve a walking-dance pat-
tern around and around,
stopping to exchange the
separately carried attributes
while rewinding the record
of their message to the world.

On each occasion the artists'
movements are naturally and
concertedly different in a
different context; but there
has also been a developmen-
tal change from their first
performance at St. Martin's
School on January 20, 1969,
to their most recent one

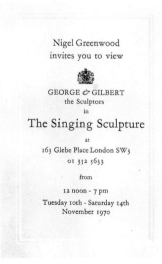

Nigel Greenwood
invites you to view

GEORGE & GILBERT
the Sculptors
in

The Singing Sculpture

at
163 Glebe Place London SW3
01 352 5633

from

12 noon - 7 pm
Tuesday 10th - Saturday 14th
November 1970

< *The Singing Sculpture* at the
Nigel Greenwood Gallery,
London, in 1970

in the Sonnabend Gallery
Downtown, New York.
Throughout 1969, the piece
included the artists' short
lecture-preface on their feel-
ings about sculpture and
being sculptors in this work;
the dance lasted through
only about three plays of the
record; the artists did not
add their human voices to the
mechanized music. Aside
from the Pop concerts and
a Movietone News and BBC
Bristol T.V. exhibition, the
contexts were mostly those
of British art schools—to an
audience of specifically in-
vited *sculptors* at the Royal
College, presenting *Our New
Sculpture* on January 23, 1969.
(For the Slade School, Gil-
bert & George personally
invited every staff member
by telephone and gave sweets
and cigarettes with spoken
invitations to all students
on the day before.) After the
summer of '69 they always

performed in metallic heads;
beginning with the first
"Between" exhibition at
Düsseldorf's Kunsthalle
the weekend of February 14,
1970, they sang *with* the re-
cording for a period of time
abstracted from the record's
scale and without the lec-
ture preface. From that time
on, part of the work has been
the time-scale undramati-
cally covered by the nonstop
performance: two days of
8 hours each at the Kunst-
halle; ten almost consecutive
8-hour days in Cologne,
Aachen and Krefeld in Octo-
ber 1970; five sequential
7-hour days at Nigel Green-
wood's Gallery, November
1970, in London; and ten
5-hour days at Sonnabend's
in New York, beginning Sep-
tember 25, 1971—plus a
couple of one-night 2-hour
stands in between.

EXCERPT
©ARTnews (New York),
November 1971

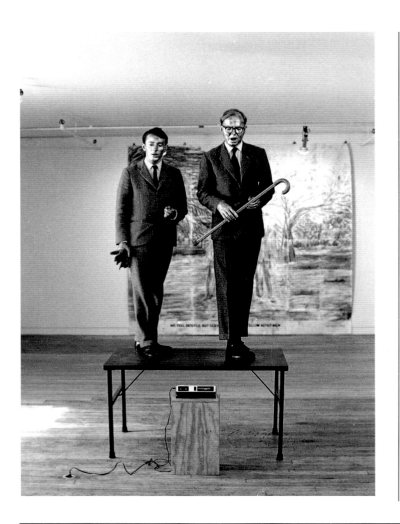

< *The Singing Sculpture* at Sonnabend Gallery, New York, September 25–October 8, 1971

Being living Sculptures
is our
life-blood
our destiny
our romance
our disaster and
our light and life.
As day breaks over us
we rise into our vacuum.
The cold morning light
filters dustily through
the window. We step into
the responsibility suits
of our Art.

Statement by Gilbert & George in
a leaflet distributed to visitors to
The Singing Sculpture at Sonnabend
Gallery, New York, in 1971

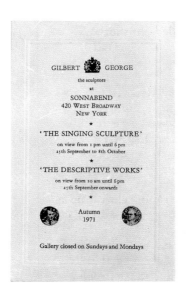

THE SYNOPTIC LOFT: U.S. COMMENTARY
Dore Ashton

We have not yet left the realm of motion and time, for there are George and Gilbert, the living sculptures, complete with sound track. For a long time it has been said that art, visual art, is being purveyed as entertainment, to which I have little objection. Here, with no expense to the customer, is live entertainment. Even better, it arrives at a moment when all of America is investing in the merchandising of nostalgia. What could be more nostalgic than these two parodies of English gentlemen, with their neat suits, assuming the postures of mannequins on a small table and singing "Underneath the Arches" on an average of once every five minutes. I suppose it rouses different sources of nostalgia. I thought immediately how much Breton would have liked it all, including the atrocious drawing on the walls. The gestures have been well studied. The two Gs look the part. The cane has a squeak on the end—the one small touch which saves. The sound track is admirable. The repetitions wonderfully exact. Everyone sat in wonderment. To think they do this all day long. What endurance. What a gas. How very…how very entertaining. What a commentary on art, on nostalgia, on English gentlemen, on the art world, on sculpture, on vaudeville. The voyage is extensive here. And the audience is given.

EXCERPT
Studio International
(London), November 1971

REVIEW OF THE SINGING SCULPTURE AT SONNABEND, 1971
Douglas Davis

"Don't miss Gilbert & George" was the phrase most bruited at the opening, last week, of 420 West Broadway, a lavishly remodelled warehouse building in the SoHo (South of Houston Street) area, in which three well-known uptown art galleries and one well-known newcomer have just established downtown headquarters. We heard it on the stairs where hundreds of art lovers in festive denim waited as long as an hour to squeeze into the packed galleries. We heard it from Leo Castelli, whose beautiful new showrooms occupy the second floor of the building—the other floors being occupied, in ascending order, by Michael Sonnabend, John Weber (the newcomer, who used to run the now defunct Dwan Gallery, on West Fifty-seventh Street) and André Emmerich. We heard it from John Coplans, the editor of *Artforum,* and from Ivan Karp, the ever ebullient director of the O.K. Harris Gallery, which broke sod in SoHo two years ago. "I'm not sure what a 'singing sculpture' is supposed to mean," Mrs. Leo Castelli confided to us, "but don't miss it."

At about four o'clock in the afternoon, we fought our way at last into the Sonnabend Gallery, and there were Gilbert and George, standing on a small table in the center of a crowded room, singing, to a tape-recorded accompaniment, a sentimental English music-hall ditty called "Underneath the Arches." They wore neat gray wool suits,

white shirts, drab neckties, and plain shoes. Their features, under a coating of metallic bronze paint, looked youthful and implacably earnest. The taller one held a walking stick with a green handle, his partner held a rubber glove, and as they sang they moved and turned atop the table with the small, stylized gestures of mechanical toys. When the song was ended, the short one took the cane from the tall one and handed him the glove; then he climbed down from the table, removed the cassette from the tape recorder, turned it over and replaced it, restarted the recorder, climbed back on top of the table, returned the cane to his partner, and took back the rubber glove. The music started, and, with the same expressionless gestures and mechanical movements, never smiling, they began to sing again, in the same way, the same song. They had been doing this since one o'clock in the afternoon, we learned, and they would keep on doing it, without a break, until six that evening.

"We found that song very biographical," George told us. "The song had meaning for us—each line meant something."

"We didn't really choose it." Gilbert said. "We just took it. Not in preference to something else but because it had a great deal of accuracy in our terms."

"There was no satirical intent at all," George assured us.

Singing Sculpture remains their central preoccupation, and they have no desire to sing any other song or alter in any way their manner of singing "Underneath the Arches."

"It's a completed work, like a painting," George informed us. "We wouldn't like to change it. We try our best to do everything the same way each time. It's not theatre, you see; it's sculpture. The bronze makeup is really more for us than for the audience; it makes us feel more like sculpture. Sometimes we think of ourselves as sculptors and sometimes as living sculptures. We tend to slip from one to the other, so to speak. We feel very devoted to art, you see."

"That's true," Gilbert said. "Totally devoted."

EXCERPT
The New Yorker, October 9, 1971

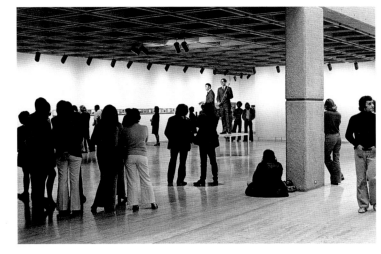

National Gallery of New South Wales, Sydney, 1973

GILBERT AND GEORGE, SONNABEND, DOWNTOWN
Robert Pincus-Witten

[Flaubert's] Bouvard and Pecuchet doing a music hall turn, figures playing at being military dolls, Schlemmer's *Triadic Ballet* and Léger's *Ballet Mécanique* in English terms.

The ambience is completed by an elaborate suite of drawings called *The General Jungle* or *Carrying on Sculpture*—the later term expressive of the pinched self-denial of English austerity measures. Although automated, their eyes still light upon a startled audience. Through thick-lensed spectacles George enlarges his myopic eyes while Gilbert grimly looks on appraisingly and ungenerously. Strange *goyim.* Their day is filled with an eventlessness transformed into occasion—"where something and nothing are both qualities," reads a caption on their drawings. Through elegant promotional activity and graphic material a glamour and importance is transmitted to the shell of a life in the way that Andy Warhol was once able to transform street life into the "Superstar Underground." Ritually performing before the stage drop of their own drawings, another caption admits that "Nothing breathtaking will occur here, but..."

What is intriguing in this "singing sculpture" is the discontinuity between the easy charcoal drawings, the mundane captions elevated to the lapidary (through hand-lettered titles) and the sheer willfulness of the project itself. These dislocations assist in transforming a tawdry event into something bitterly sad, stirring emotions which defy classification—into art I suppose. The "singing sculpture" is whole unto itself.

EXCERPT
Artforum (New York), December 1971

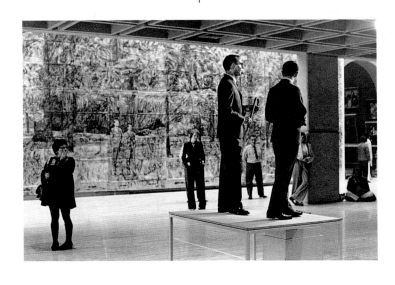

< *The Singing Sculpture* at the National Gallery of New South Wales, Sydney, Australia, in 1973

CHRONOLOGY OF
THE SINGING SCULPTURE

OUR NEW SCULPTURE

1969 St. Martin's School of Art, London

 Royal College of Art, London

 Camberwell School of Art, London

THE SINGING SCULPTURE

1969 The Lyceum, London

 National Jazz & Blues Festival, Plumpton

UNDERNEATH THE ARCHES

1969 Slade School of Fine Art, London

 Cable Street, London

1970 Kunsthalle, Düsseldorf

THE SINGING SCULPTURE

1970 Kunstverein, Hannover

 Block Gallery Forum Theatre, Berlin

 Kunstverein, Recklinghausen

 Heiner Friedrich Gallery, Munich

 Kunstverein, Nuremberg

 Wurttembergischer Kunstverein, Stuttgart

 Museo d'Arte Moderna, Turin

 Sonja Henie Niels Onstad Foundation, Oslo

 Stadsbiblioteket Lyngby, Copenhagen

 Gegenverkehr, Aachen

 Heiner Friedrich Gallery, Cologne

 Kunstverein, Krefeld

 Nigel Greenwood Gallery, London

1971 Show Room du Garden Stores Louise, Brussels

 For BBC play "The Cowshed," London

 Sonnabend Gallery, New York

1972 Kunstmuseum, Lucerne

 L'Attico Gallery, Rome

1973 National Gallery of New South Wales, John Kaldor Project, Sydney

 National Gallery of Victoria, John Kaldor Project, Melbourne

1991 Sonnabend Gallery, New York

SELECTED
BIBLIOGRAPHY

Carter Ratcliff, *Gilbert & George 1968 to 1980.* Exhibition catalogue. Stedelijk Van Abbemuseum, Eindhoven, 1980.

Gilbert & George: The Complete Pictures 1971–1985. Exhibition catalogue with an introduction by Carter Ratcliff. Thames and Hudson, London, 1986. German and French editions published by Schirmer/Mosel, Munich. Spanish edition published by Centro Nacional de Exposiciones, Madrid.

Wolf Jahn, *The Art of Gilbert & George.* Thames and Hudson, London and New York, 1989.

Gilbert & George, *The Cosmological Pictures, 1989.* Exhibition catalogue. Edizioni Carte Segrete, Rome, 1991.

Gilbert & George: New Democratic Pictures. Exhibition catalogue. Aarhus Kunstmuseum, Aarhus, Denmark, 1992.

ACKNOWLEDGMENTS

I am extremely grateful to Gilbert & George for making their archive available and for their patient assistance and support during the development of this book. Special thanks are due their archivist and assistant, Mirjana Bukvic Winterbottom.

I would also like to thank Ileana Sonnabend, Antonio Homen, Anthony d'Offay, and Robert Violette for their enthusiasm and help; Judy Adam and Ngaere Macray for their valuable suggestions; Clive Philpott, librarian at the Museum of Modern Art, for making his archive available to me; Lisa Farrington for her assistance in preparing the editorial material; and especially John Bernstein, the designer.

The excerpts from interviews and reviews by Anne Seymour, Caroline Tisdall, Douglas Davis, Dore Ashton, and Robert Pincus-Witten have enlivened and brought immediacy to the historical section of the book. I am grateful to them for granting us permission to reprint these pieces. The same section is made concrete by the contributions of numerous photographers. In most cases I have sought permission and credited their work. In a few instances the pictures were not labeled, and the photographers were impossible to trace. I thank them also.

Anthony McCall